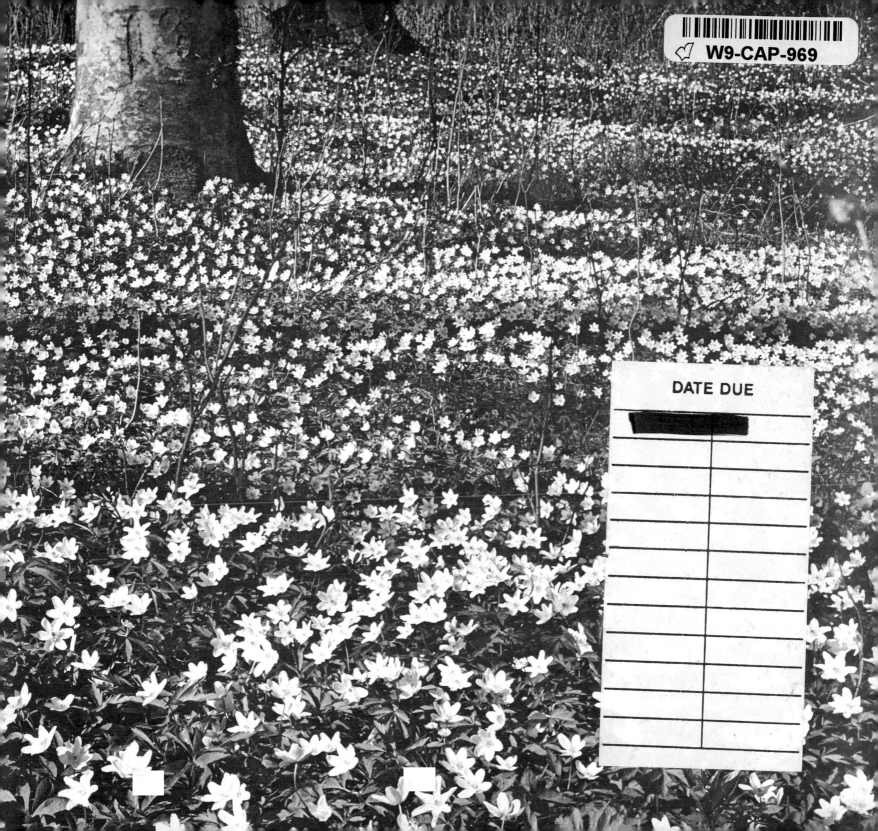

DATE DUE

The cover picture was taken by Renate Holmåsen using a Voigtländer Vito Automatic with a 2.8/50 mm Lanthar lens. Agfacolor CT 18.

End-papers: wood anemones in a beechwood near Skärva, in the south Swedish province of Blekinge. Taken using a Sinar 9 × 12 cm with a 150 mm Symmar. Reproduction from an Agfachrome 50S transparency, which provides greater opportunities of contrast control. A transparency (or negative) has a far wider contrast range than a print, whether the print is produced photographically or lithographically.

Nature
Photography

Ingmar Holmåsen

Ziff-Davis Publishing Company
New York

CONTENTS

Originally published in Swedish as
NATURFOTOGRAFERING
Copyright ©1976
Interbook Publishing AB
Designed by the author
Translated by Roger Tanner

Library of Congress Catalog
Number 80-50607
ISBN: 0-87165-082-7
Printed in Italy by A. Mondadori, Verona

'Our new awareness can generate a cosmic and biological life sense enabling us to accept with humility the modest part we have been given to play in the totality but at the same time filling us with veneration at the great honour of being included in this totality.'
Rolf Edberg: *A House in the Cosmos*

My way

If I were to try to write a 'complete book of nature photography', it would turn out to be thick and expensive. In this book, therefore, I shall keep to things which I have tried myself and I shall only put forward suggestions that I believe are worth saying. Some of these things may only interest the specialist, while other things may be of more general relevance. I have devoted a fair amount of space to inexpensive but good photographic aids. Some of the illustrations are accompanied by specifications of the equipment used, but this does not imply that cameras, etc. of other makes are inferior.

My approach to photography is a documentary one. I expect my pictures to inform the spectator about the organisms and/or their environment, but a documentary and technically good picture can have elusive overtones. If I have any feeling for the natural phenomena I am photographing, this is bound to show up in the pictures. For example, how do I choose my subject? Do I take any trouble deciding my camera angle? Is there an artistic experience involved, or do I take the picture in a particular way because I want to make more money out of it?

The picture is finite, reality is infinite. The picture is two-dimensional, reality is three- or four-dimensional. When I am outdoors with my camera, my comprehension of the subject is influenced by smells, sounds, previous experiences and the feelings of the moment. These are things which can never be fully conveyed to others, but one can always try; this is a challenge to be met. The present book is concerned with the technical aspect of nature photography, and I have seen no need for discussing the rules of picture composition.

This is not a book for beginners. The emphasis is on my own experience of nature photography, from landscape to macro. I have used simple language which will give useful information. Included is a glossary of all except the elementary photographic terms I have used.

My thanks are due to Inge Laurin and Peter Ugander of Stockholm for their help.

Ingmar Holmåsen

Choosing a camera

The predominant film format today (apart from 126 and 110) is 24 × 36 mm, or '35 mm' as it is usually called. The single-lens reflex (SLR) camera is the obvious choice for the wide variety of nature photography with which this book is concerned. In the past few decades, camera manufacturers have concentrated mostly on developing these cameras, and the extensive 35 mm SLR systems have everything one could possibly wish for in the way of lenses and other accessories. If there is a camera that handles very easily and one feels that being good friends with this camera is the main thing, the choice will be simple. Weight can be an important consideration: perhaps you need an extensive system and will have to carry it for long distances. The fact is that 35 mm cameras are not as small as they used to be. Recently I took down my old 9 × 12 cm Voigtländer Avus plate camera, with its double bellows and 135 mm lens, from the 'museum shelf' and weighed it. I then weighed my newly purchased Nikkormat EL with its 55 mm Micro-Nikkor. Its weight was exactly the same as the Voigtländer, and yet there are many 35 mm cameras which are a good deal heavier. A motorized camera with a special viewfinder and a 400 mm telephoto lens (which is useful to have for unexpected encounters with animals) can mean wandering about with between three and five kilos of equipment hanging from your neck. One manufacturer, the Olympus Optical Company, has started going in for a light-weight SLR system, and in time no doubt others will follow the example. It is a boon to

mountain trekkers, for instance, that an SLR camera with through-the-lens (TTL) metering and macro lens can weigh as little as 660 grams (Olympus OM-1).

One would also like to see a different film format. The 24 × 36 mm format is far too long and narrow, and it does not fit the photographic paper formats or A4 and the other DIN formats for printed matter of different kinds. Due, however, to the enormous investments that have been made in both the still photography and 35 mm cine sectors, it will be a long time before any changes occur, for example in the form of a narrower perforation.

It is sometimes said that publishers and magazine editors are unwilling to accept the 35 mm format but one of the biggest repro-

The abundance of camera makes on the market can be more confusing than enlightening.

duction firms in Stockholm estimates that 90 per cent of its incoming colour material is 35 mm. Thus the 35 mm format predominates even among professional photographers. These cameras are superior to the larger formats in terms of handiness and availability of fast lenses. The trend towards increasingly fine-grained film emulsions and improved precision also suggests that the future of the 35 mm format is assured.

Medium format cameras (4.5 × 6 cm-6 × 9 cm) can give superior picture quality, especially when one has to use highly sensitive emulsions. To photographers using colour and monochrome together, one of the advantages of these cameras is that many of them have interchangeable film magazines. Conversely they suffer from the disadvantage of the heavier mass of the mirror and focal plane shutter, which move during the exposure and are liable to cause blurring with prolonged exposures (1/30-1 sec. approx.). Another hazard is that the picture is liable to be unevenly exposed if the focal plane shutter does not accelerate fast enough. When a tripod is used, camera shake can be eliminated if the mirror can be locked in the 'up' position before the shutter is released — especially if the camera has a central shutter in the lens. In the latter case, there is no risk of the picture being unevenly exposed.

Not many nature photographers use large format cameras (9 × 12 cm and upwards), because they are heavy, their applications limited and they are slow and cumbersome. But they are unbeatable for technical quality, especially as regards depth of field. With their adjustable front and rear standards they are first-class tools for photographing plant societies and forest interiors without any distortion. The quality of the picture is seldom dependent on the price of the camera — as witness the cover picture for this book, which was taken by my wife using an inexpensive automatic 35 mm camera bought in 1962.

Whatever type of camera you may choose, get to know it properly. Use the viewfinder frequently; the camera sees things differently from the human eye. If there are several lenses to choose from familiarize yourself with their different ways of looking at things. After a period of practice one knows immediately what lens to use when a certain type of picture presents itself.

The big scene

Landscape photography requires the least extensive range of equipment. Much can be achieved with one or two lenses. The landscape stands still, the light is generally sufficient for hand-held exposures, and there is time to work out the best angle. Because landscape photography is so easy, it is difficult to take unusual pictures. One has to be out of doors a great deal, and one must have an eye for the changing light conditions and the ability to predict and wait for the 'right' lighting. Sunlight varies with latitude, the time of year, the time of day and cloud structure. The nature photographer has to be ready to seize opportunities, for a constellation of factors in certain surroundings may suddenly appear and then vanish.

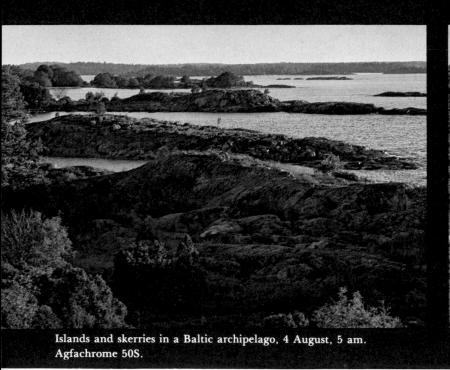
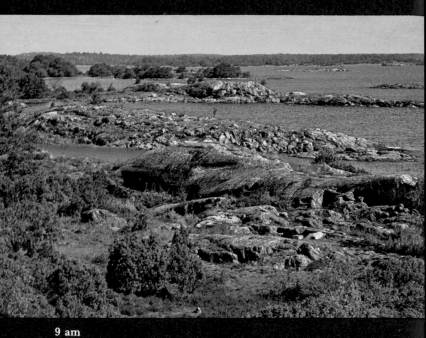

Islands and skerries in a Baltic archipelago, 4 August, 5 am. Agfachrome 50S.

9 am

Daylight

The Minolta colour temperature meter.

The above series of pictures, taken one bright August day, illustrate the changes undergone by the colour temperature of sunlight during the day. The lower the sun's position in relation to the horizon, the farther its beams must travel through the atmosphere and the greater the proportion of short-wave, ultra-violet and blue radiation absorbed by the atmosphere. Thus the lower the sun is, the more yellow it looks, and immediately above the horizon it appears to be red, especially where the atmosphere is more polluted. To counteract these variations one can use light balance filters — blue to compensate for yellow light, amber to counterbalance blue light, for example when photographing something in the shade

The Minolta colour temperature meter.

10

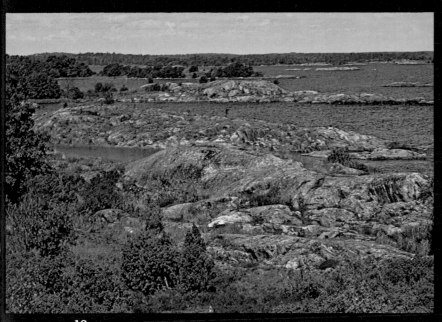

12 noon

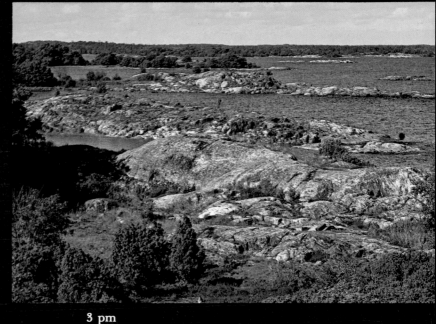

3 pm

on a clear day. In order to know how strong a coloured filter is needed, use a colour temperature meter. This is expensive, however, and with a little practice one soon learns to judge for oneself which filter is most suitable. One does not always want to even out the natural variations of the light altogether, and for such decisions a meter is only an approximate guide. Photographers using several camera systems are advised to invest in adapter rings, so that they can use the same set of filters with all their cameras. The quality of the atmosphere is of crucial importance to the long-distance photographer. When the above series was taken, the air was unusually clear for the height of summer. The only radical solution to the problem of penetrating mist is to use infra-red film, but with the highly specialized infra-red films on the market it is impossible to obtain a natural tone range.

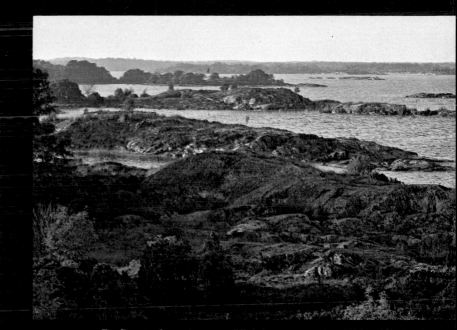

By 7 pm the mist has thickened considerably.

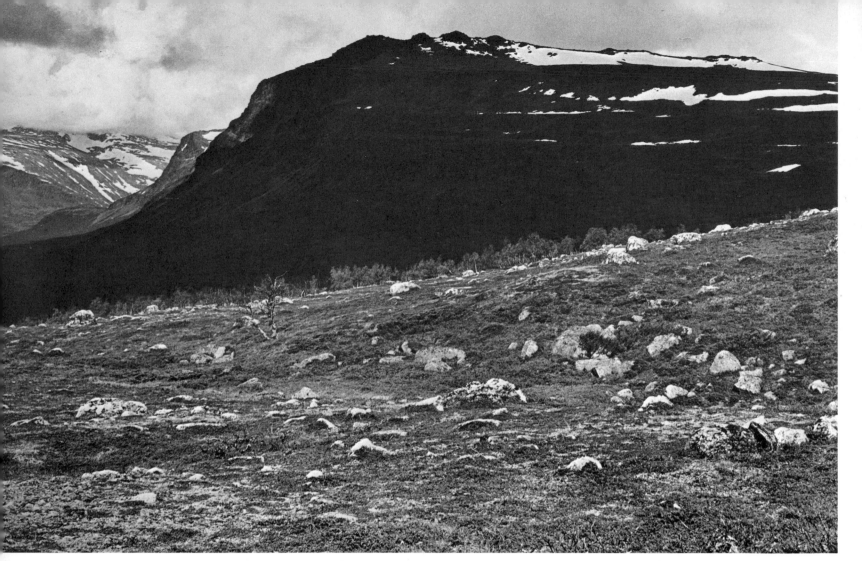

Päljasj (Arctic Sweden) in the shadow of a cloud. Taking using a Pentax SP with a 50 mm Super-Takumar. Tri-X, D-76.

Waiting for the light

The landscape photographer is almost wholly dependent on natural lighting, but it is worth remembering that this is not a constant factor. If there is broken cloud, for instance, the play of the light over the ground is constantly changing. All one then has to do is to wait for the lighting one is looking for. In the above picture, the mountain slope is shadowed by cloud while the foreground and background are more or less in sunlight. An exposure of this kind should be worked out according to the sunlit portions of the picture. If one goes by the dark mountainside, the sunlit portions will be seriously over-exposed: this is essential for the colour photographer to bear in mind.

Many landscape pictures stand or fall by

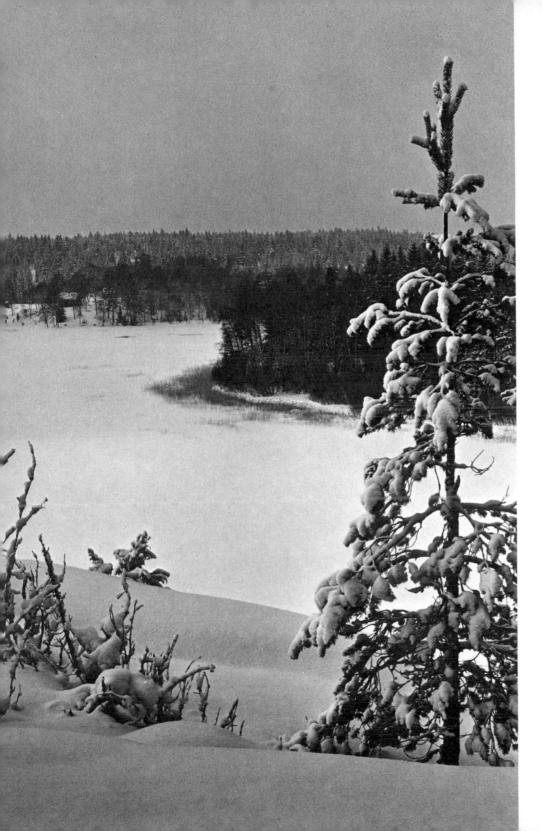

their lighting: the unusual light situation makes the picture. The chance of capturing a special atmosphere in the scenery is particularly good early or late in the day and in connection with variable weather conditions.

The seasons

For recording long-term changes in the landscape, the camera has potentialities far superior to those of our unaided recollection. Even a simple series such as the four seasons in a particular stretch of scenery can vividly convey the variety of the living landscape. Each individual season displays an infinity of variations. The only limitation lies in our ability to recall the appearance of objects five of fifty days ago. Unconsciously, we adjust to the changes around us, changes which are brought home to us when the pictures are placed alongside each other.

Nor is any one year exactly similar to its predecessor. A meadow which was white with scentless mayweed one July can be yellow with St. John's wort the next. Autumn colours too, develop differently from year to year, depending on when the frost sets in and the number of hours' sunshine.

This picture of an 'isolated' season makes a somewhat static impression: the landscape appears unchangeable. If, however, the four seasons are placed side by side, the pictures take on a new dimension — *time* (overleaf).

13

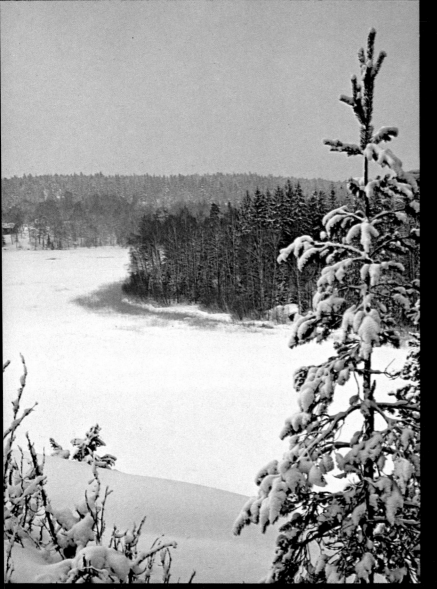

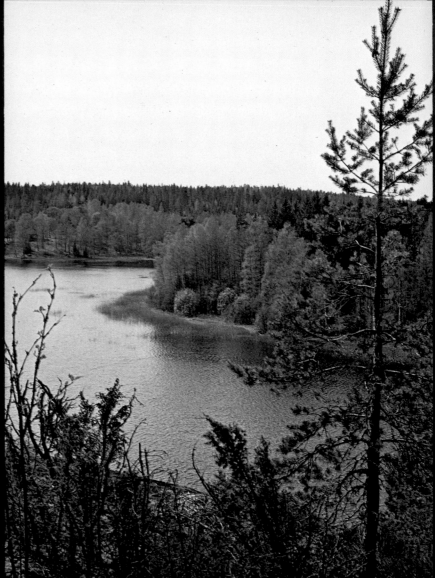

10 March. The yellow remains of last year's reeds are one of the few touches of colour. If the woodland is deciduous the landscape will be more 'transparent' than at any other time of year The snow acts as an enormous reflector screen, which is a great help with woodland interiors.

16 May. The light green foliage stands out in contrast to the dark green of the conifers. The lake is waiting for its new vegetation. In the deciduous forest there is still plenty of light which contains only an insignificant element of green.

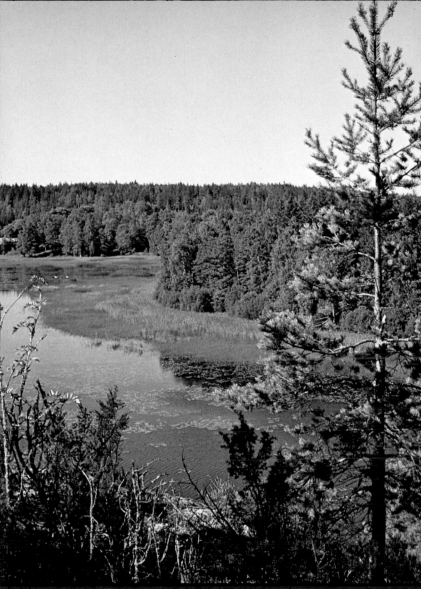

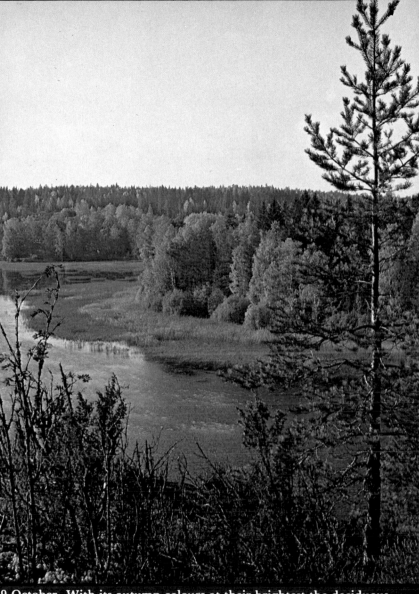

13 August. The vegetation is fully developed and at its most lush and bright. The border of reeds and bulrushes has turned green once more, and the surface of the shallow lake is partially covered by water lily and pondweed leaves. This is the most difficult time of year for woodland photography, because there are so many contrasting shades of green that pictures taken in a deciduous forest often acquire a greenish tint.

9 October. With its autumn colours at their brightest the deciduous forest stands out in sharp contrast to the conifers. This is a good time of year for aerial photography on dry, clear days.

Hasselblad 1600F and 80 mm Tessar. Agfacolor CT 18.

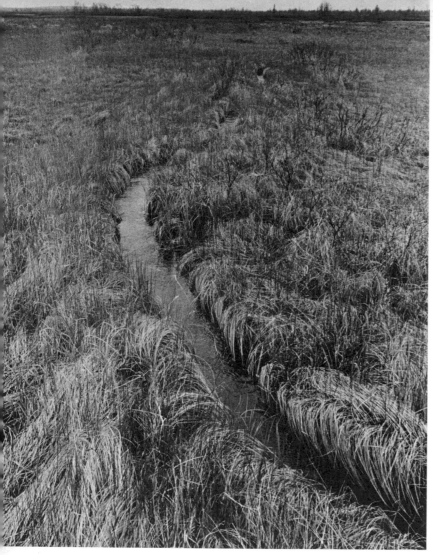

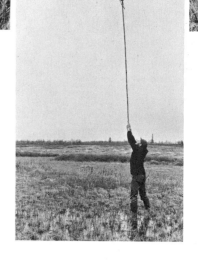

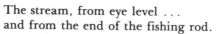

The stream, from eye level . . .
and from the end of the fishing rod.

The overall view

There are many features of the landscape which do not reveal themselves until viewed from above. Before travelling to the Sjaunja marshes in Swedish Lapland in 1972, I devoted some thought to the problems I was likely to encounter. I took two sections of a fishing rod, so that the camera was assured of some kind of a perspective view of the flat country. The built-in self-timer with its 10-second delay gave me just time enough to hoist the camera aloft and aim it with what accuracy I could muster; wide angle lenses are to be recommended.

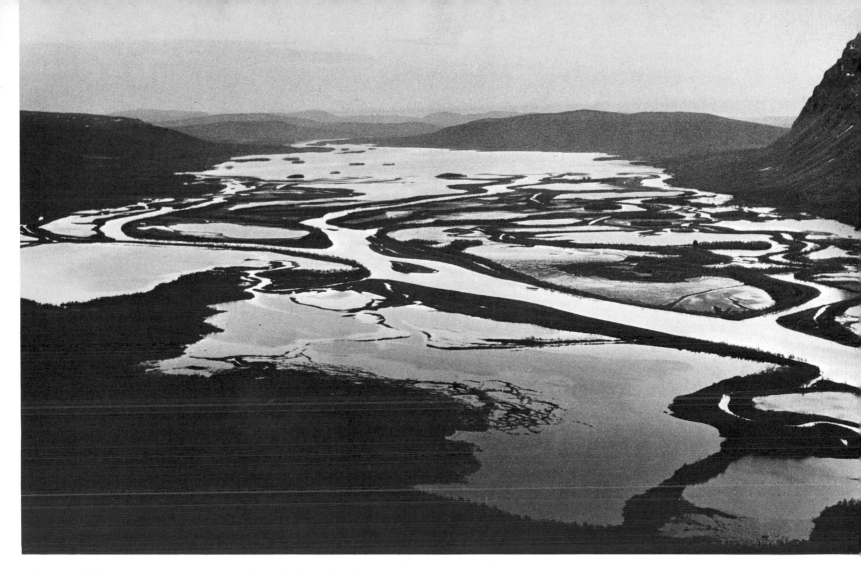

Low sunlight brings out the undulation of the landscape, heightening the contrasts. This picture was taken in the midnight light of the Lapland summer. The sky lights up all the water surfaces of the Laidaure delta against the dark background of the dry land.

Aerial photography

Hiring an airplane or a helicopter is an expensive but efficient way of getting an overall view of the landscape. Clean air is one of the main essentials of aerial photography. Polar air coming in behind troughs of low pressure is best. Ridges of high pressure often bring clear air to start with, but usually the haze will gradually thicken, at least in summertime. Often it is not until one is actually airborne that one can see how much of a haze there really is. Use the fastest possible shutter speed, because the ground goes by quicker than it seems, and air pockets can never be predicted. Do not lean the camera against the body of the aircraft (vibrations!). Keep the window open: the perspex spoils the sharpness and is liable to give reflections.

17

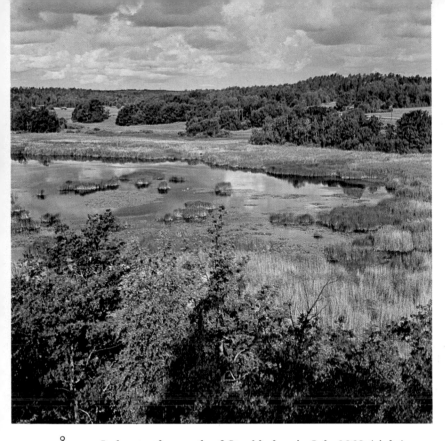

Ågesta Lake, to the south of Stockholm, in July 1962 (right) and July 1974. Even without the nutrient salts derived from agriculture and human settlement, such a shallow lake on fertile soil would inevitably become overgrown. But the process is now moving faster than ever. The picture from 1962 also serves to illustrate how shortlived some colour slides can be. Most of my transparencies from the late fifties have retained their colours, however, so that one is inclined to suspect variations in the developing process.

The changing scene

The fissures of this Baltic archipelago are clearly visible from about 300 metres up. Hasselblad EL with 80 mm Planar. Exposure time 1/500 sec. Agfachrome 50S.

Any landscape photograph of acceptable clarity will eventually acquire documentary value. Changing methods of farming are resulting in rapid transformations of the landscape, which as we know it today is almost entirely man-influenced, with the exception of certain marshland and mountain areas. One need only consult pictures taken between the 1950s and 1960s and then revisit the location to see the great natural and artificial changes that occur within such a limited period. In recent years the archives of earlier photographers have attracted increasing attention. If the pictures can be identified they present opportunities of comparative shots that may span half a century or more.

Nikkor 15 mm

24 mm

55 mm

105 mm

20

35 mm

24 mm. From the same position as with the 35 mm. The perspective is the same, but the picture angle is wider.

200 mm. The longest telephoto lenses give the best proportions between the different elements in the picture, but they shorten the depth.

Perspective

Decide your perspective *when you choose your vantage point*. This determines the relative positions and sizes of the details in your picture. Your choice of focal length then determines *how much of the scene* will be included in your photograph. Vantage point and choice of lens are of the photographer's most important means of expression. If the foreground predominates and the background is to be insignificant, close in with the camera and use a wide-angle lens, but to be 'neutral' use a normal lens. To bring out the background, back well away from the scene and use a telephoto lens — the longer it is, the more prominent the background will be. If details of pictures could be enlarged without any sacrifice of technical quality, only the shortest of the wide-angle lenses would be needed.

21

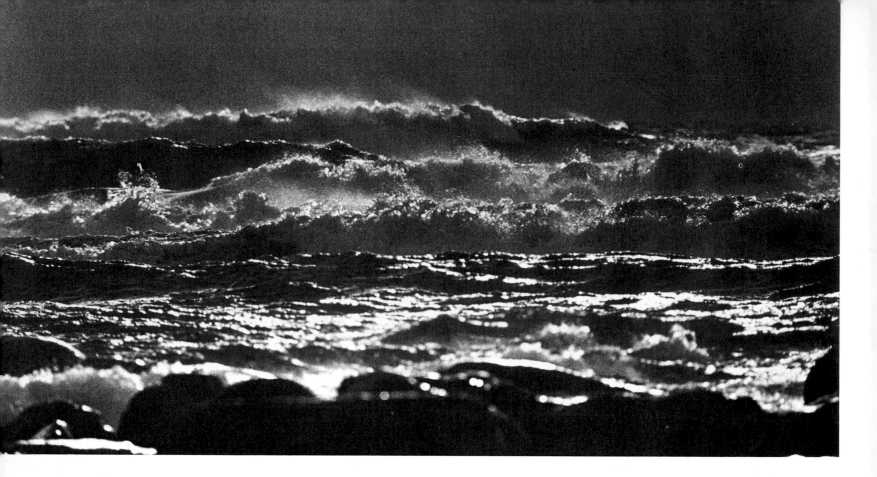

Bringing out differences of level

Long lenses bring out differences in height. These breakers were photographed with a Hasselblad 1000F and an 800 mm Telon. Such a long lens protects the camera from spray during rough weather. Protect your camera with a stout polythene bag with a hole cut in the bottom for the camera lens. Fasten the bag round the lens hood with a rubber band. Protect the lens hood with an ultra-violet or skylight filter. The bag must be big enough for your hands to move freely inside. Do not cut another hole for the viewfinder window: you will see through it quite clearly, and the plastic will stop it from getting steamed up. Low sunlight from one side is good for bringing out differences in height. The pictures opposite show the changes that take place in autumn colours in just two days. Overcast weather gives pastel colours; sunshine increases the contrasts. (Hasselblad 500C, 250 mm Sonnar, Agfachrome 50S.) The left-hand picture was damaged twice in processing. The colourless rings are due to water splash and can be removed by means of re-rinsing and drying. The black spots are patches of the picture which have not been developed, due to foam in the developer; nothing can be done about this.

A plastic bag shields the camera from rain and spray.

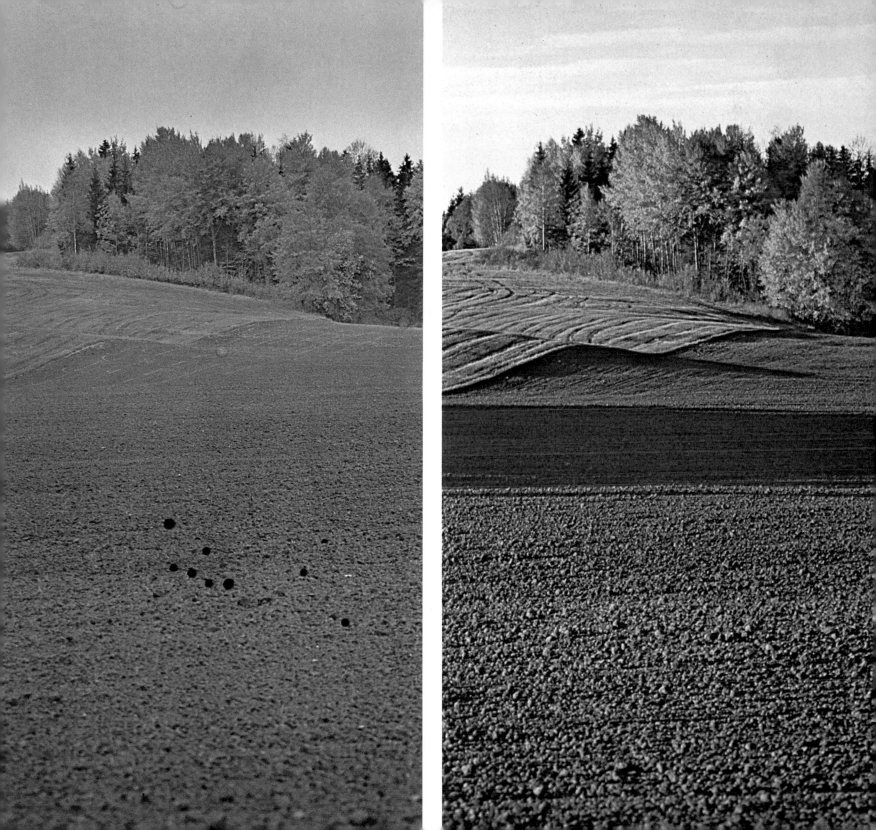

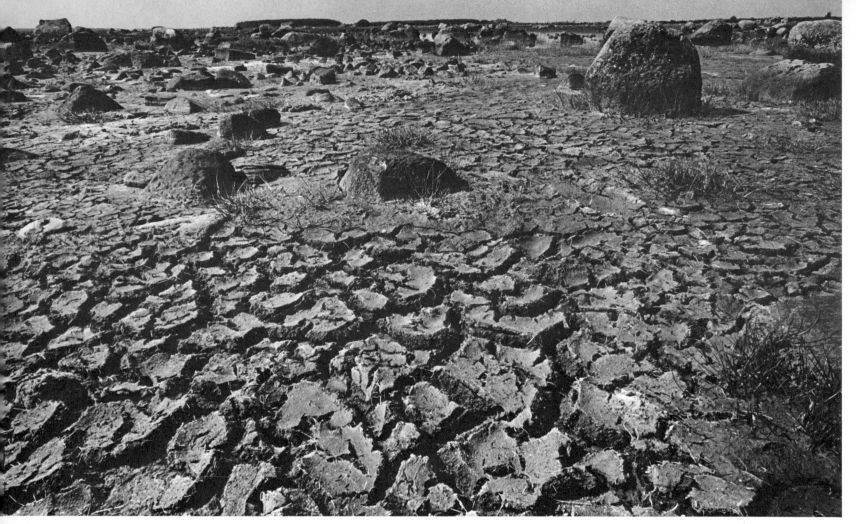

The mud flats on this Baltic island have been cracked by the drought.
Pentax SP, 20 mm Flektogon.

Level and undulating country

Wide expanses of country gain by being photographed from a low level and with a wide-angle lens. The short focal length gives the desired depth of field and also brings out the extent of the country. The positioning of the camera means everything here. A shift of only a few decimetres can transform the picture entirely. By varying the focal length, one can take completely different pictures from the same vantage point. Looking at the top picture (opposite) one is almost oblivious of the mountain in the background. The main focus of attention is on the cotton grass in the foreground. Focal length is entirely a matter of taste. Make use of the possibilities that your equipment offers you.

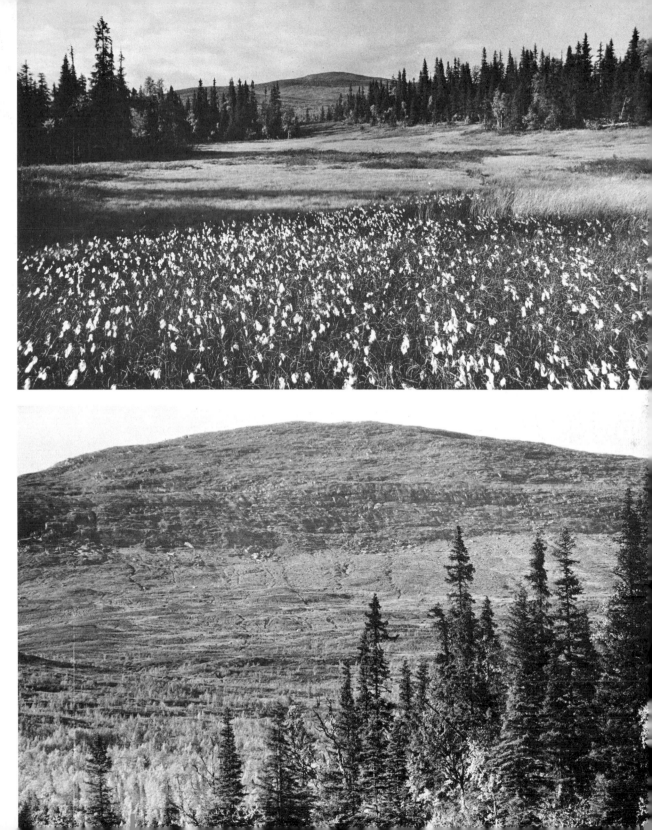

Sipmege, on the border of Sweden and Norway. Nikon F, 24 mm Nikkor.

Taken from the same camera position but with a 200 mm Nikkor.

ND filters

Neutral density (ND) filters can be used in both monochrome and colour photography to reduce the general light content of the scene. The reason for doing this may be to avoid stopping down and getting too much depth of field, or that the film is too fast for the subject, so that one does not have high enough stop numbers and shutter speeds. But a suitably designed filter of this kind can also be confined to selected parts of the picture. The Hasselblad professional lens hood shown above takes 3×3 in. gelatine filters. The lens hood can be turned round and the gelatine filters are inexpensive enough to be cut to shape if necessary. If one stops right down, one can see via the focusing screen what position the filter should be taped in for the desired effect. ND gelatine filters are available in densities ranging from 1/3 to 6 2/3 stops increased exposure. In the two examples shown here a 2-stop filter was used to subdue the sky lighting. The top picture of pasque flowers was taken without a filter. The bottom picture was taken with an ND filter for the sky and the water, plus a blue light balance filter over the whole picture to subdue the yellow.

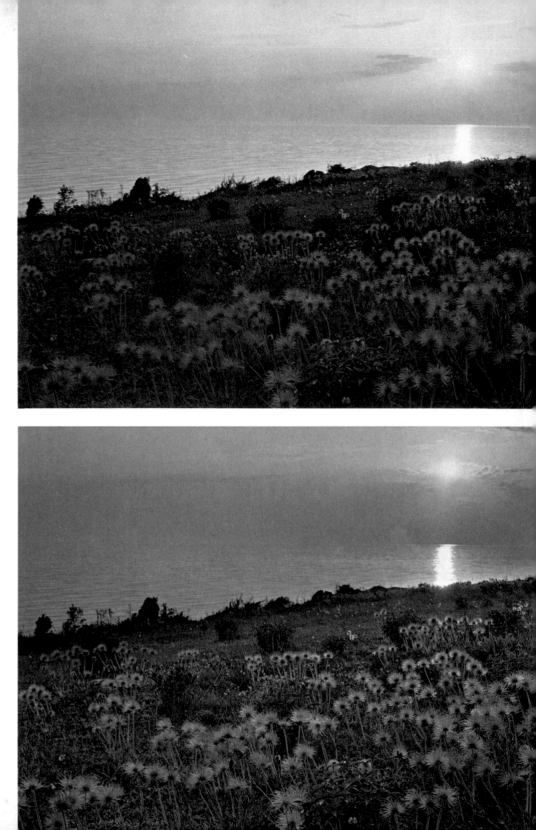

Filters for black-and-white film

Today few landscape photographers seem to use filters with monochrome film. Panchromatic films do agree fairly well with the colour sensitivity of the human eye, but many of the pictures one sees in print would have greatly benefited from the use of a filter. There can be other reasons for using filters besides the need to subdue the blue of a bright sky, to which films are still somewhat hypersensitive. Differently coloured parts of a picture reflecting the same degree of light assume an identical shade of grey on the film (and in the print) unless a suitable filter is used to articulate them. The basic rule is that those parts of the scene which are the same or roughly the same colour as the filter reproduce lighter (in the print) while other colours come out darker; they are absorbed by the filter. Generally it is the complementary colour of the filter that comes out darkest. Blue, however, is an exception. A red filter absorbs blue to a far greater extent than yellow, which is the complementary colour of blue. Natural colours are so composite and 'impure' that one can often make a more accurate assessment of filter effect by holding the filter in front of one's eye than by following the theoretical system of complementary colours, which occupy diametrically opposite positions on the colour scales to the right. As can be seen, colour compensating filters also have effect on monochrome film. When polarized light is absent, the polarizing filter will have no effect on the colour rendering.

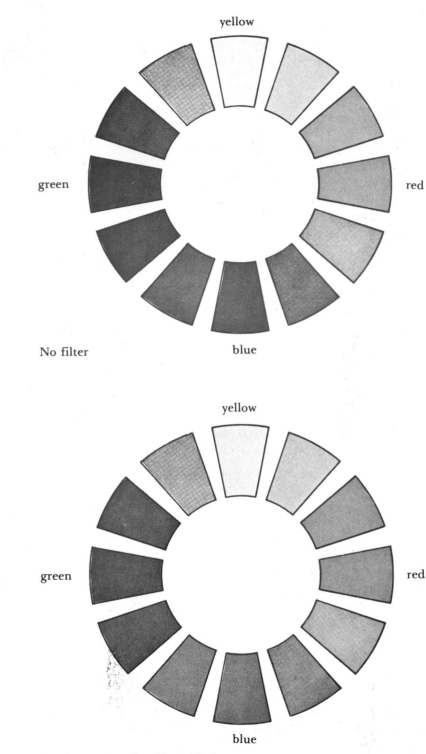

No filter

Red colour correction filter CR 12

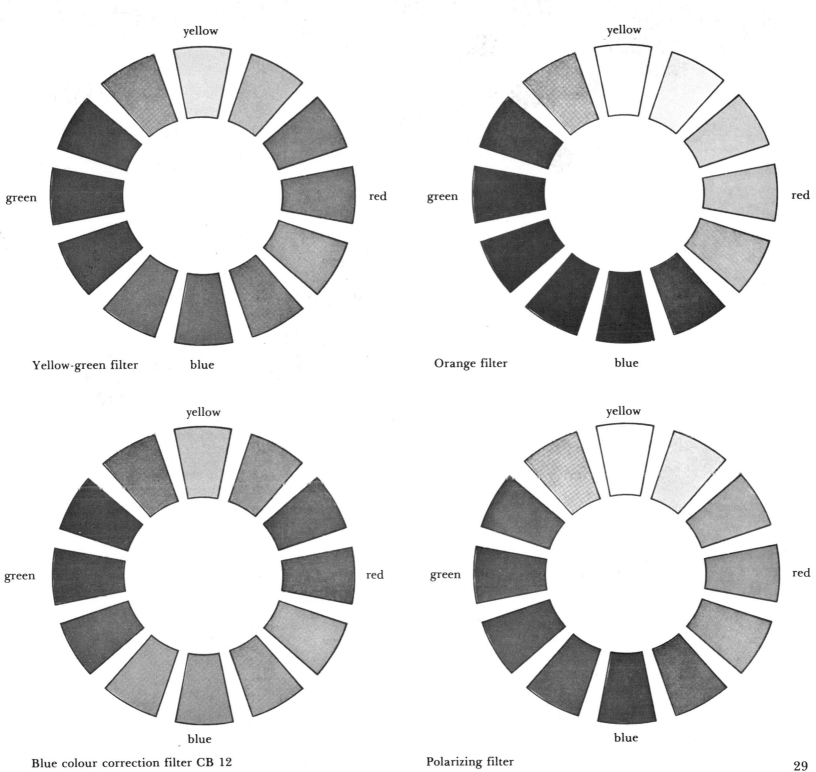

yellow

green

red

Yellow-green filter blue

yellow

green

red

Orange filter blue

yellow

green

red

Blue colour correction filter CB 12 blue

yellow

green

red

Polarizing filter blue

Polarizing and skylight filters

Sometimes the colour photographer also wishes to tone down the blue light of the sky to obtain a greater contrast to the clouds. This can be done with a polarizing filter which is neutrally grey. Light waves oscillate in all directions, at right angles to the direction of radiation. When it is reflected by nonmetallic surfaces, light is polarized and no longer oscillates so. This polarized light can be almost extinguished with a polarizing filter. The sky's diffuse light is also polarized, especially at right angles to the beams of the sun. Thus to get the strongest effect have the sun to the left or right of the direction in which you are aiming the camera. When using a polarizing filter, rotate it in its mount until you can see on the focusing screen that you have obtained the effect you require. The exposure has to be increased by 1-2 stops. TTL-metering is a great advantage in this connection, since only the light which reaches the film is measured. Polarizing filters have equivalent effects on monochrome films.

The air molecules diffuse the blue part of the spectrum more widely than the red part. This is also the reason for the blue haze one sees in the distance, which is sometimes an asset to landscape photography but can also be a handicap. In the latter case the photographer uses skylight (haze) filters, which are light amber.

35 mm PC Nikkor, no filter.

A polarizing filter gives the sky a deeper shade of blue. The greenery also takes on a richer colour. The thousands of reflections from all the shining leaves are eliminated.

400 mm Noflexar, no filter. This lens gives a distinctively cold colour reflection.

The 200 mm Nikkor is more neutral. The pictures were taken on the same occasion, using the same roll of Kodachrome.

The skylight filter (R 1.5) sold by Novoflex to fit their 400 mm lens is a fairly strong amber and therefore improves the colour rendering a great deal.

Consequently the Nikon's skylight filter (L1A) is practically colourless and has little effect on the colour rendering.

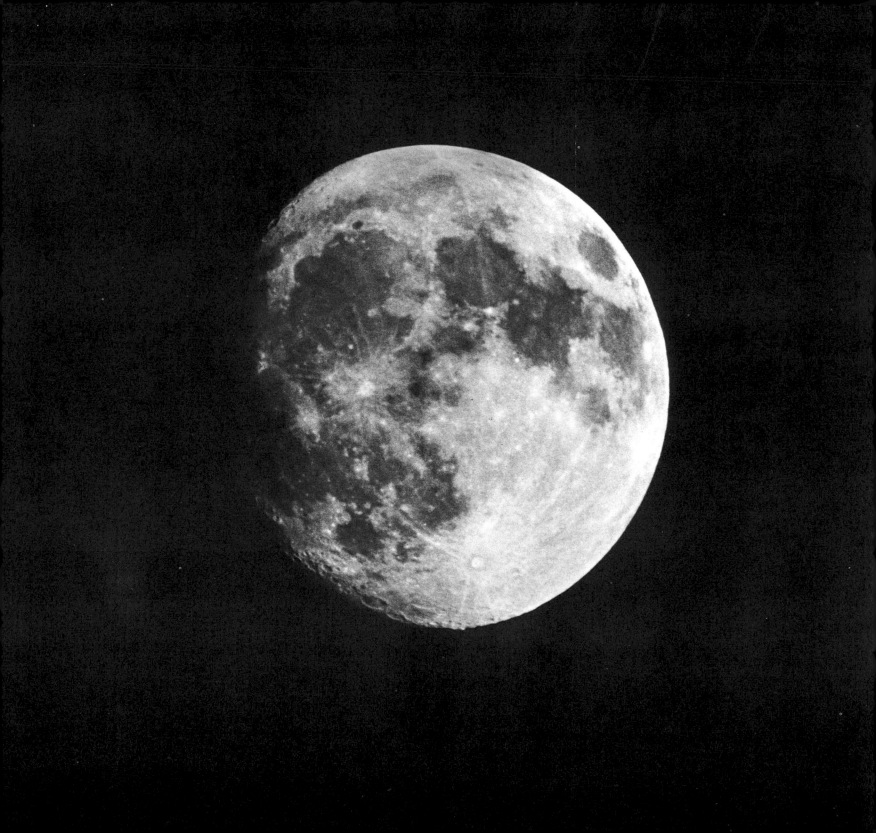

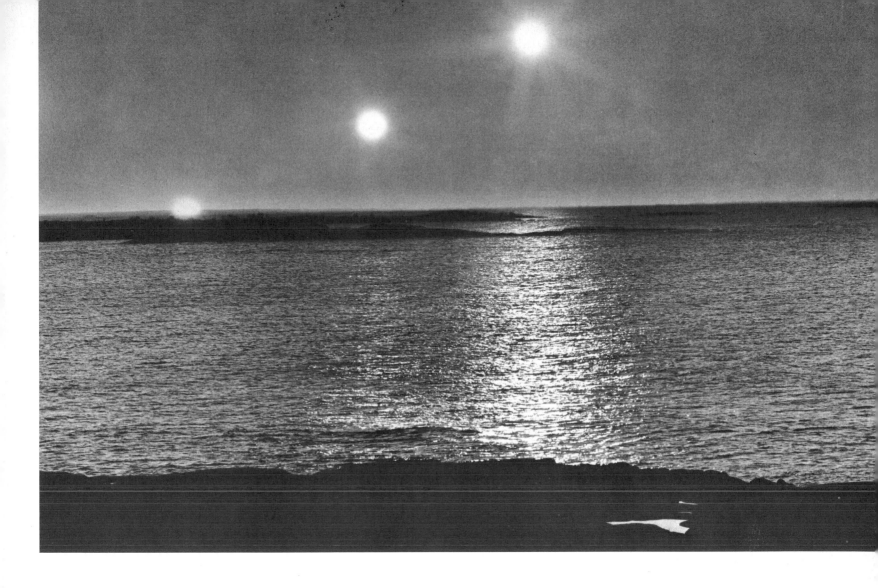

The heavenly bodies

The craters can be seen at their clearest where the sunlight sweeps over the moon's surface. The picture was taken two days before full moon. If it had been taken at full moon, the shadows would have disappeared and the craters with them.

are nature on the grand scale, but they are difficult to photograph without astronomical apparatus.

The full moon oposite was taken with a Reflex-Nikkor 1 : 11, 1000 mm mirror lens. Exposure time: 1/60 sec., using Ilford Pan F —the subject being sunlit. For the craters to come out clearly the atmosphere must be

clear with the moon well above the horizon so that the light will have less distance to travel through earth's turbulent atmosphere. The moon's diameter on the negative is 10 mm, which is 1/100 of the focal length.

The triple exposure of the sunrise was under-exposed by one stop for the first exposure and one-and-a-half for the second and third.

Hasselblad 500C and a 150 mm Sonnar.

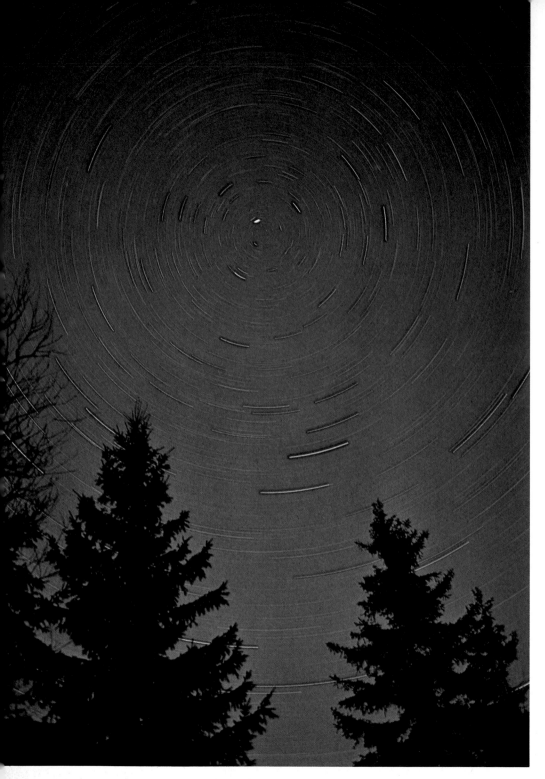

The night sky

This picture was taken one clear, moonless winter night, 20 km from the nearest human settlement to avoid any distracting light on the particles which are suspended in the air even on a clear night. The camera, a Nikon F with a 1.4/35 mm Nikkor, was aimed at the pole star. Maximum aperture and one hour's exposure time. In that time the earth turns through 1/24 of one revolution and each individual star draws its arc. Film can 'accumulate' light, even a film as slow as (in this case) Kodachrome II. Furthermore, the colour rendering varies considerably from one make of film to another. Understandably enough, my first attempt was made with a fast colour film, but this proved quite unsuitable for the purpose.

Sunsets

Every nature photographer must at some time have tried his hand at sunsets. In the days of the separate selenium light meter, the rule of thumb to under-expose by two stops used to work. With the built-in TTL-meter, the safest method is to measure with the sun just outside the picture area — assuming one is using a telephoto lens to get a decently sized solar disc. A picture taken with a 400 mm lens gives a solar diameter of about 4 mm on the film if the lens is focused sharply. But if the lens is heavily out of focus (picture on extreme right) the sun will look far bigger. The enlargement produced by the blurred focus gives a darker hue to the edge of the sun, resulting in a three-dimensional effect.

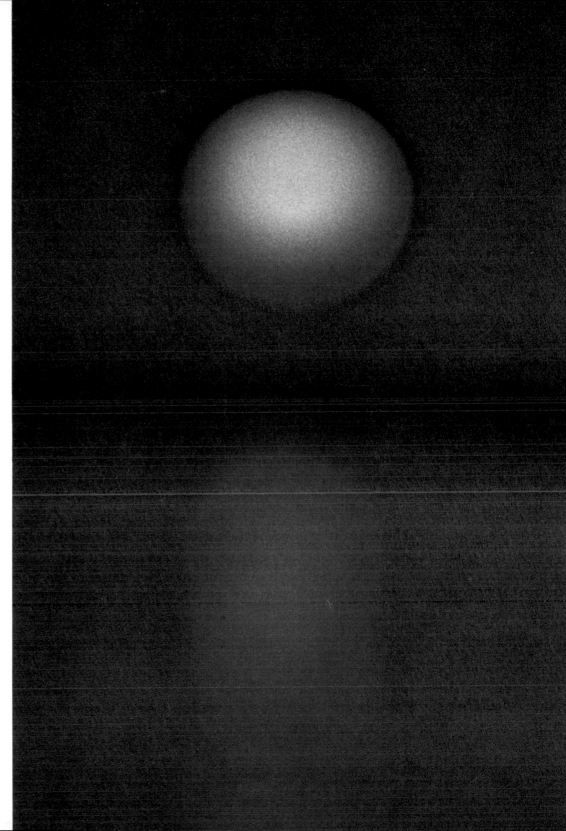

Bright sunshine with little haze gives a nocturnal effect if one is to avoid over-exposing the sun. Pentax SP with (above) a 20 mm Flektogon; a 400 mm Noflexar was used for the other two pictures.

Woodland

A woodland is a highly variable biotope, ranging from pine-clad moorland to dense groves of deciduous trees. In deciduous woodland, 'light climate' and colour temperature vary a great deal from one season to another. When the ground is covered by snow, the light is reflected against the shadow sides of the trunks and branches. At the height of summer and towards autumn, the light is filtered through the leaves, giving a greenish illumination which can be counter-balanced with a magenta filter. At this time of year the light is at its most difficult, because brilliant sunlight in a dense forest covers a far wider range of contrasts than a film is capable of bridging. Even in the thin oak forest shown to the right, overcast weather is best for documentary purposes (Nikon F with 50-300 mm Zoom-Nikkor set at 87 mm).

If you are determined to get the most you can out of woodland photography, and are prepared to carry a lot of weight, the large format camera is definitely the best proposition. With it you can control distortion, set your focal plane where you want it and generally do everything that possibly can be done with a camera. Increasing numbers of 35 mm cameras are now being equipped with PC (perspective control) or shift lenses with quite a powerful restitution effect (right-hand side). Their focal length is usually 35 mm, although it may be 28 or 65 mm. The Canon TS (Tilt and Shift) lens can also be titled for increased depth of field. The same goes for the Austrian Varioflex (p. 57).

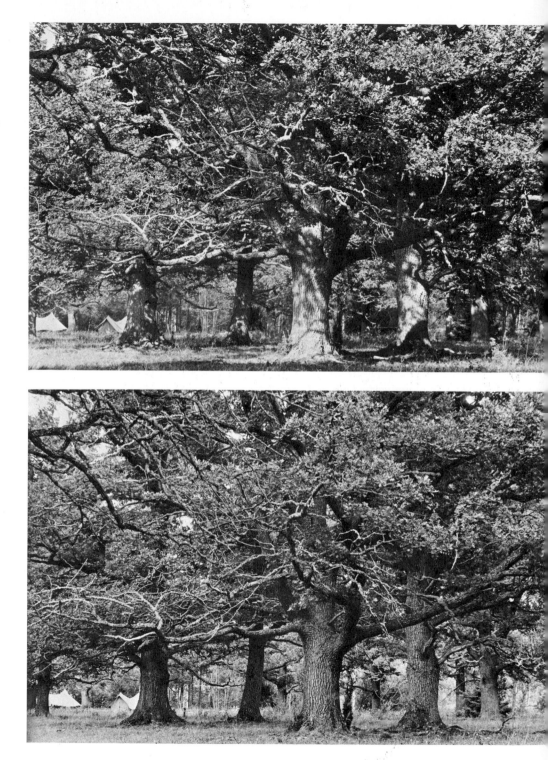

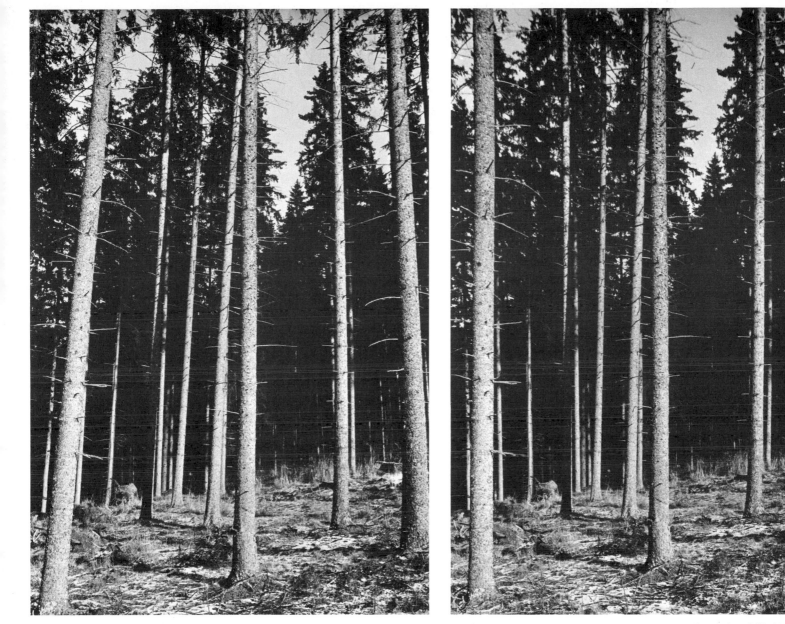

As soon as you point a camera upwards and the film is no longer parallel to the vertical lines of the picture (the tree trunks), you get this sort of distortion. PC-Nikkor in the normal position.

In this picture, maximum use has been made of the shift (11 mm) of the PC-Nikkor lens. The film plane is vertical = parallel to the tree trunks. Thus the lens has been moved 11 mm upwards.

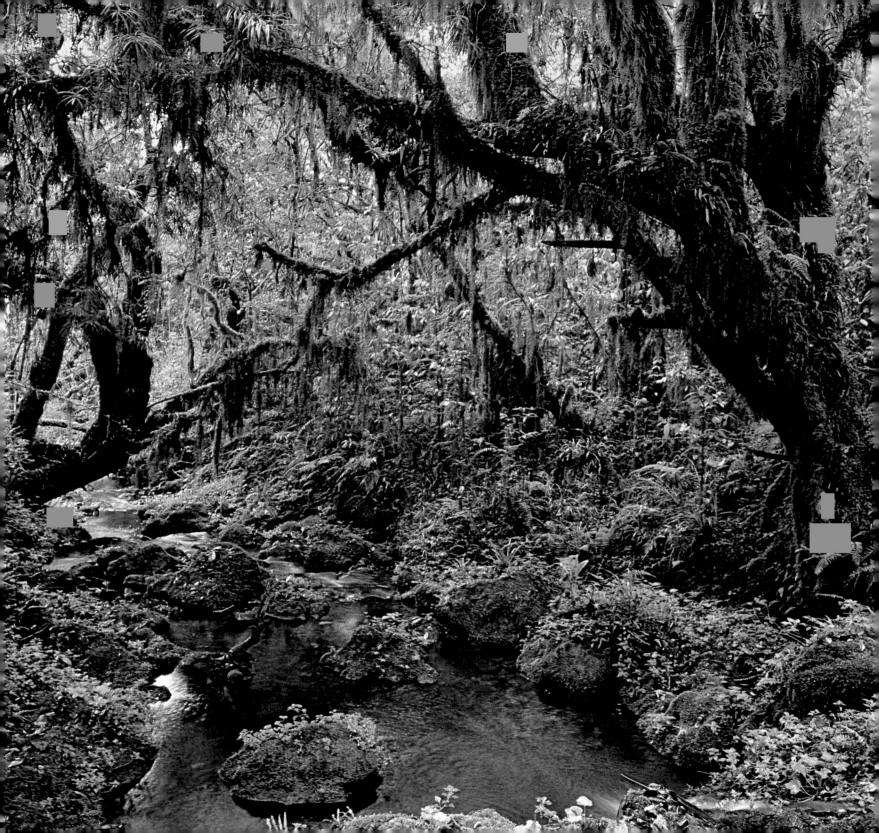

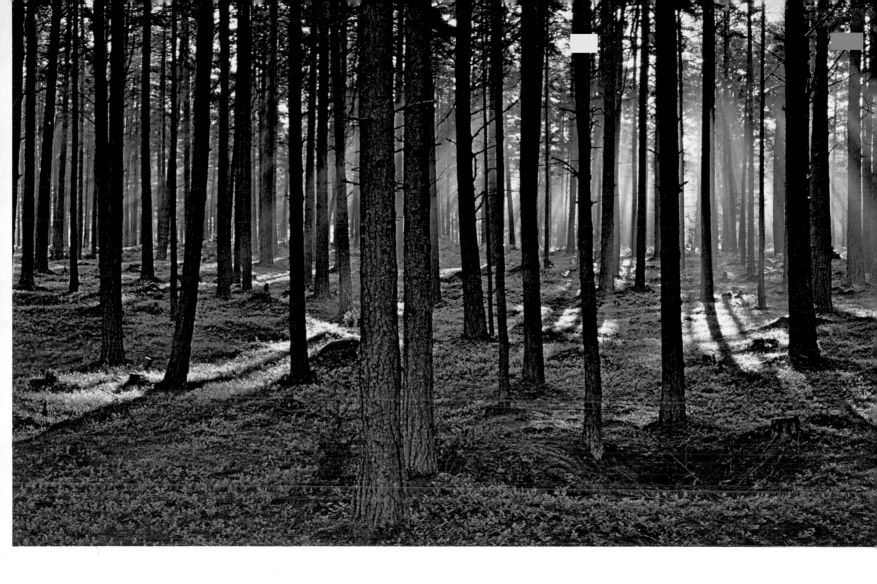

Green light

The rain forests of Kilimanjaro resemble a manifold green filter, producing a 'natural' green tint which the eye — or rather, the brain — compensates for when we are in the forest but not when we are looking at the picture out of context. Hasselblad 500C with a 50 mm Distagon. Agfachrome 50S.

Blue and yellow light

In this vast pine forest the yellow light of morning meets the blue skylight weakly illuminating the shaded sides of the trees from the other direction. The back lighting lends added depth to the picture. The exposure was a compromise between the sunlit and shaded parts of the scene. Nikon F with a 55 mm Micro-Nikkor, Kodachrome II.

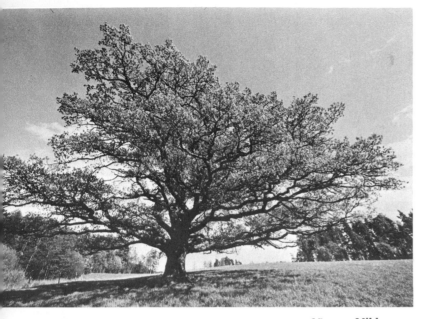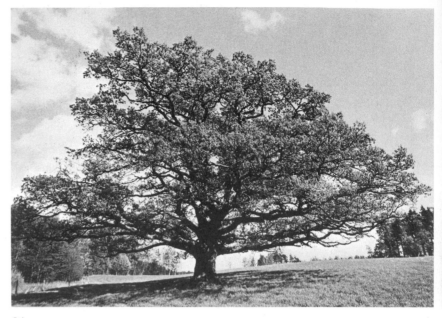

15 mm Nikkor 24 mm

Plants

There is no hard and fast boundary between landscape and plant photography. Wherever trees can grow, they have a great effect on the appearance of the landscape. One may look for individual trees to illustrate the typical shape of the crown of a certain species and they may take some finding! Or one may show how differently the tree develops when it has to grow in close proximity to other trees, when it is exposed to low winter temperatures, drought or strong winds. Trees are the oldest living organisms we can photograph, and no one can follow the development of a tree throughout the whole of its life. Apart from full-length portraits, every type of tree presents close-up and macro subjects: buds, blossoms, cones, fruit, seeds, leaves, needles, bark, knots, roots and woods as well as mosses, lichens, fungi and all the insects and other forms of animal life associated with a particular species of tree.

The series of pictures on these two pages shows how differently the same oak tree can be depicted by varying distance and focal length. All the pictures were taken from the same direction with the same scale of reproduction. The shorter the focal length, the more spacious the crown will seem. The crown also looks larger because the branches are so much nearer the camera than the trunk. At the greatest distances, using the telephoto lenses, the crown becomes compressed and relatively small. The difference between the distance of the crown and that of the trunk from the camera no longer matters, because the distance between tree and camera has increased by several hundred metres.

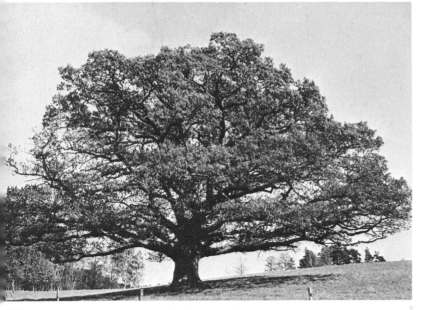

55 mm

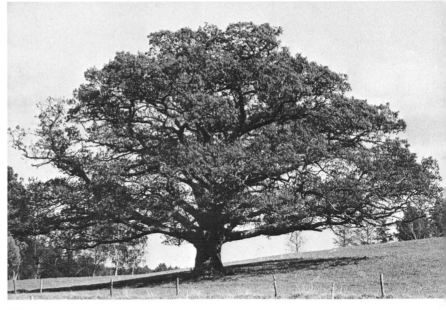

105 mm

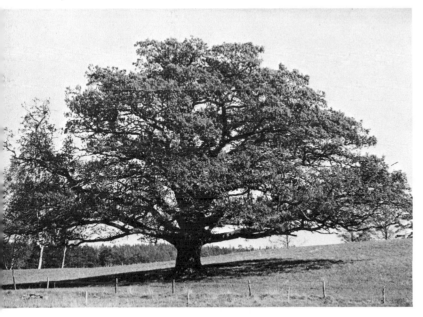

200 mm

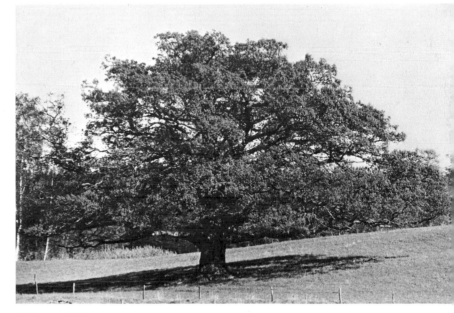

400 mm Soligor

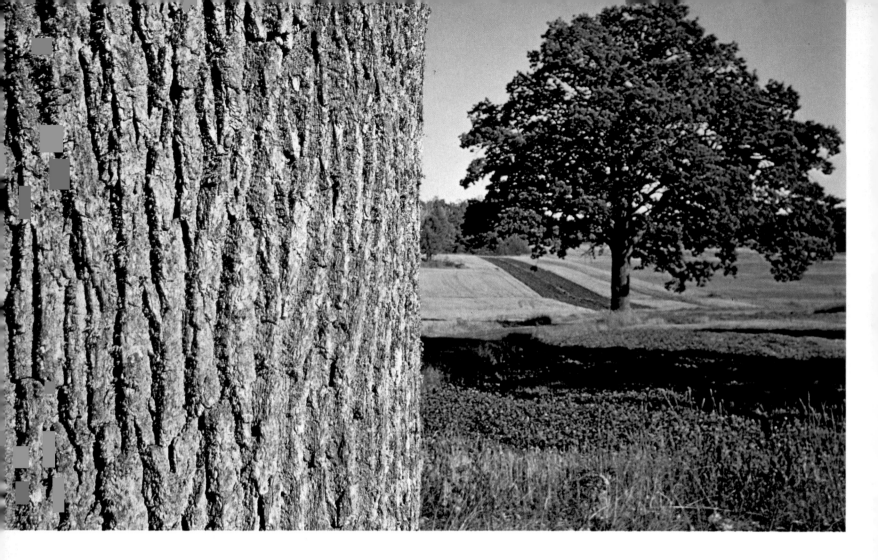

The educational picture

A wide-angle lens (35 mm) and f/16 will give
sufficient depth of field for a hand-held ex-
posure showing both the bark structure of an
oak trunk and another oak full length. Focus
on the foreground or just behind it, other-
wise neither foreground nor background will
come out in focus. Kodachrome II.

42

Unreal reality

Young aspen trees. The extremely wide angle
gives the foliage a semi-abstract appearance,
and the pattern gains in depth because the
leaves get smaller the further away they are
from the camera. The depth is also brought
out by the cold light on the leaves' shaded sides
in contrast to the background leaves.

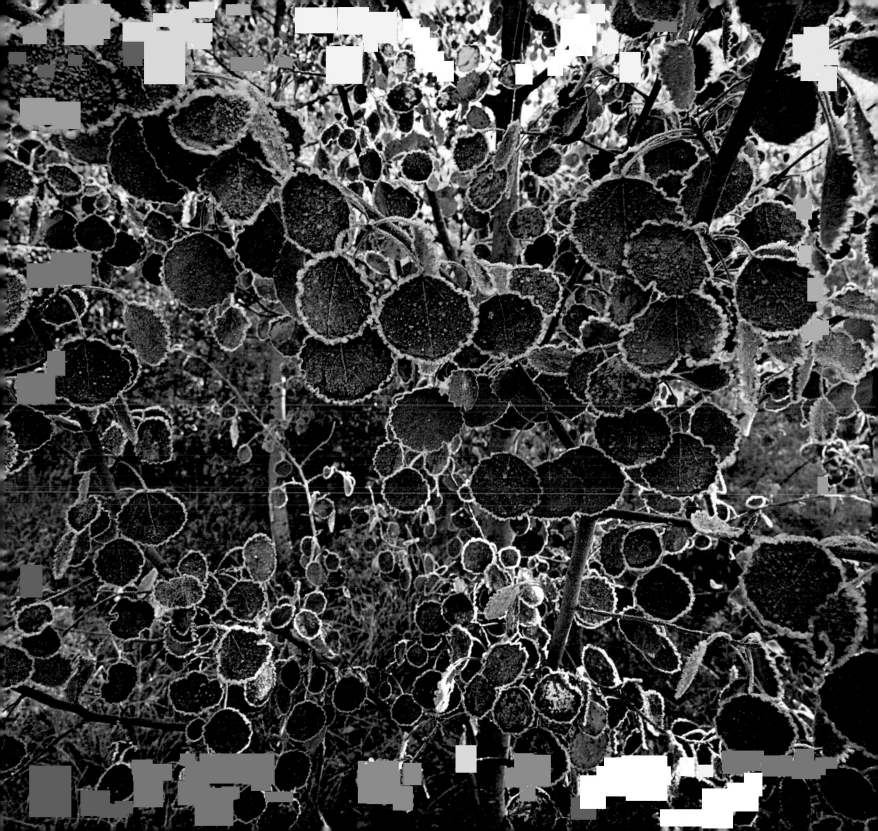

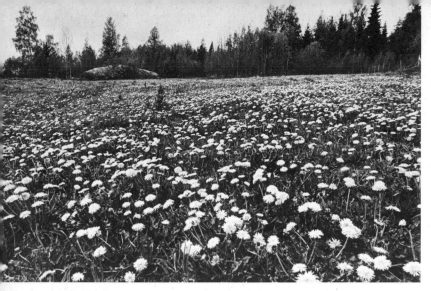

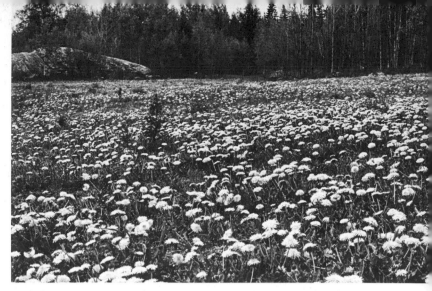

With a 24 mm wide-angle and with the camera kept close to the ground, the flowers in the foreground come out large and easily recognizable. Because of the short focal length, the flowers rapidly diminish in size as the picture recedes, and they seem rather widely scattered. The picture brings out the breadth of the field.

The normal lens (55 mm) produces a picture with no striking characteristics. The size of the flower diminishes at a 'normal' rate from foreground to background. There is still enough depth of field, because of the small aperture. All three pictures were taken at f/16 and with the camera at the same level.

Plant societies

Assume that you wish to show certain herbs in their natural environment. Distance, camera angle, focal length and depth of field are extra important here. You must choose between making a few plant representatives dominate the foreground at the expense of their surroundings or taking a more general picture in which it will be hard to see the details of the plants. This is particularly critical if the picture is going to be reproduced in newspapers or by other procedures involving the use of coarse line screen and cheap paper. The best arrangement is to take several pictures: general and close-ups. But if you have to get as much as possible into a single picture, there are many things to be considered. The pictures on this page, taken with different focal lengths, are examples.

A 200 mm telephoto lens compresses the picture and narrows the field of vision. There is now less difference in size between the flowers closest to the camera and those furthest away. Although the lens has been stopped down almost to the smallest aperture, the depth of field is still not enough.

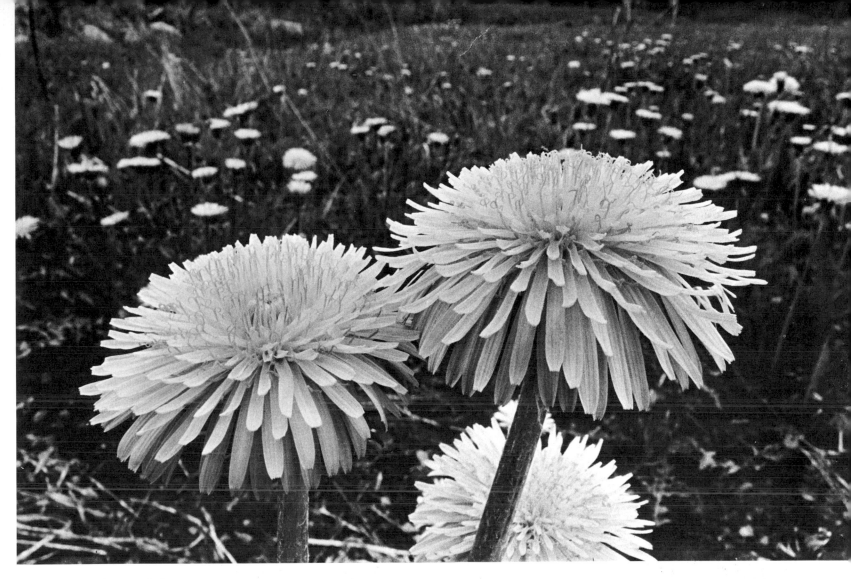

Two prize specimens of the common and flourishing dandelion genus. Pentax SP with a 20 mm Flektogon (an East German lens with the unusual closest focus of 15 cm).

Wide angle for close-ups

In close-ups of plants extremely wide angles show details in the flowers, and, if the lens is stopped right down, their surroundings, too. Often the lens cannot be focused close enough. Extension rings that are thin enough are hard to find and the definition is not always sharp enough. Fast wide-angle lenses are seldom calculated for close-up photography: if they have floating lens elements, this improves the sharpness. If you use this lens with an extension ring, you have to set the focusing ring at the closest focus, or the floating lens elements will not serve their purpose.

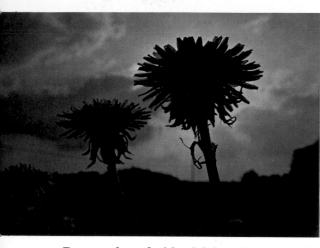

Do not be afraid of lying down on the ground with your camera to get fairly long exposure times —1/15 sec. or even more— with the camera hand-held. In extreme back lighting (the sun is hidden by the flower in the above picture), you cannot rely on the TTL-metering. An integral meter is excessively influenced by the brightness of the sky. A spot meter may allow you to measure in detail on the shaded side of the flowers. 24 mm Nikkor.

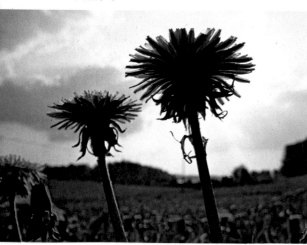

This was the result when I doubled the exposure time indicated by Nikon's centre-weighted integral meter.

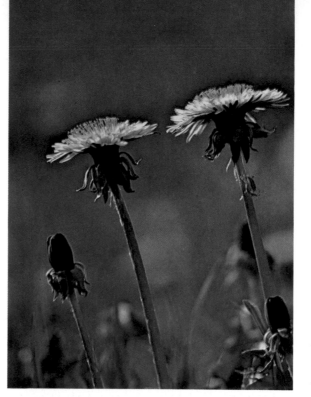

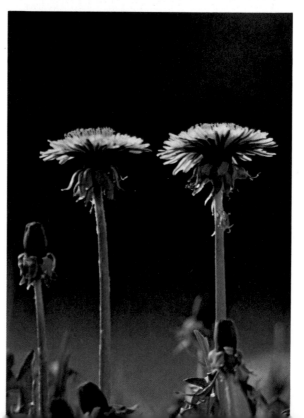

Telephoto for close-ups

A moderate telephoto lens (90-135 mm for 35 mm cameras) is useful for plant portraits to get a blurred background and the plant's details. A longer focal length (200 mm here) limits the field of vision even more which makes it easy to vary the background. But increased focal length can cause camera shake due to the movements of the mirror or shutter, or the wind shaking the equipment. A tripod is essential (p. 64). In the top left picture the background was a sunlit meadow. By lowering the camera I got a dark background in the lower picture. The integral meter has to be corrected by ½-1 stops 'underexposure' to avoid overexposing the dandelions, as the meter is greatly influenced by the dark background. All exposure meters are calibrated for 'average light' subjects. Remember this when measuring against subjects of different reflectance.

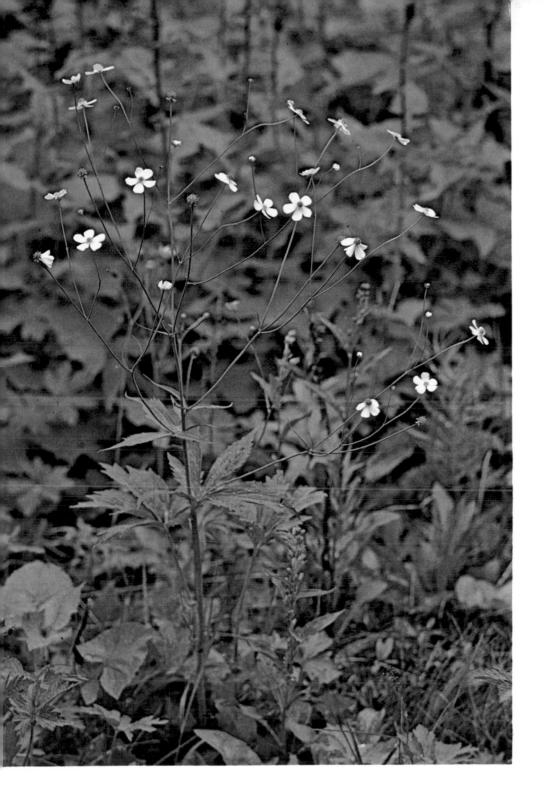

The wind

This is the kind of adverse situation that a plant photographer must always be prepared for: a long branching plant swaying with the wind, set in a muddled background.

There was no wind at all on this cloudy July day in the mountains of northwestern Sweden. It was the perfect weather for plant photography. A 105 mm telephoto lens brought the large white buttercup clear of its background. The aperture had to be chosen so as to bring the entire plant into focus without the background becoming obstrusive. Different plants often tend to be intertwined, in which case a certain amount of 'gardening' is inevitable if you are to get a decent picture of the *species*. If you are out to portray a *plant society*, you should leave things as they are.

A screen of some kind can help to keep the wind off, if the plants you are photographing are not too big. This shield of plastic foil can also be used to soften up hard sunlight. You can enclose the plants completely in a plastic tent, but in this case the plastic must be perfectly transparent if you have to photograph the background *through* it.

47

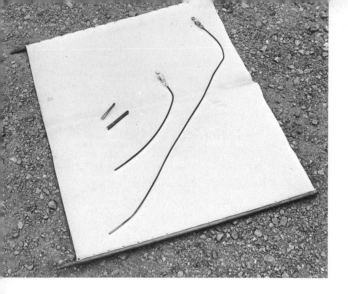

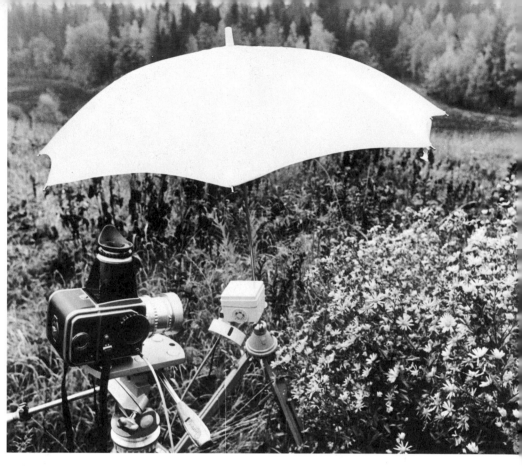

I have used this white PVC screen as a wind shield and a reflector to brighten up shadows. On the screen (above) are two stout, flexible copper wires of different lengths, each with a clip at one end, and two U-shaped aluminium holders. The clips are of the type used for accumulators. The air seldom stays still for the long exposure times that are needed for macro pictures of individual flowers. I put the aluminium holder round the stalk of the flower, because the clip could damage the plant. All this trouble can be avoided by taking the plants indoors but then the atmosphere of the natural environment is lost.

If the wind is too strong for anything to hold the plant, or if the light is too poor, a flash may have to be used in spite of the disadvantages. An umbrella reflector greatly softens the hard light of the flash. The large concave expanse of the umbrella reflects the flash, giving a soft light resembling subdued sunlight. When folded, the umbrella can be carried around with no trouble whatsoever, and the model in the above picture was bought from Arrowtabs, Ltd., London, at a very reasonable price. An arrangement of this kind gives a kind of indirect flash, and inevitably a certain amount of light is lost: this particular model made about 2 stops difference to the exposure.

If they are translucent, umbrellas can be used not only as flash reflectors but also as a means of softening up sunlight.

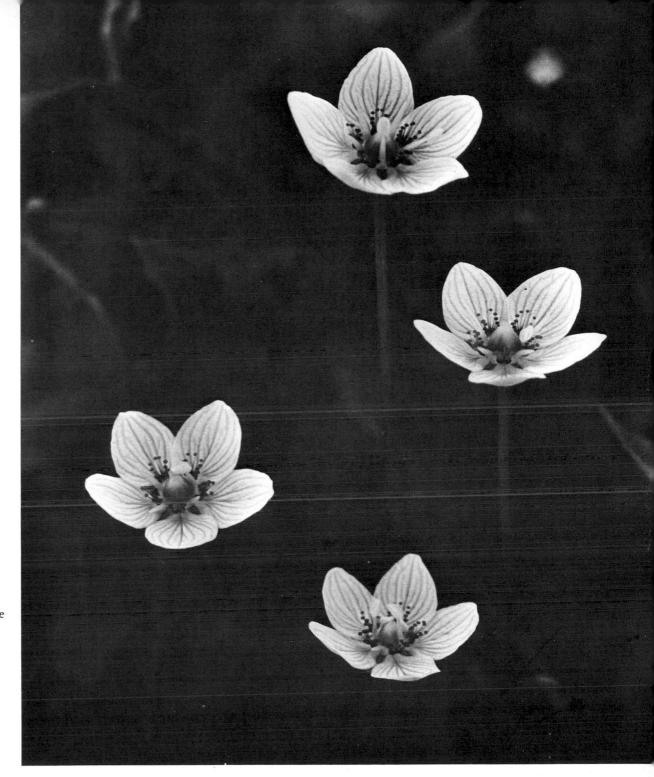

If you take care to put the focus exactly where it is needed, you can sometimes use full aperture and still get enough depth of field for the essentials of the picture. These four grass-of-Parnassus flowers were a fortunate discovery: although their stalks were of different lengths, the cups were all on the same oblique plane, with the result that the film plane could be kept parallel to all four flowers, thus obviating a small aperture (and with it a slow shutter speed). A calm background lends added prominence to the subject. Hasselblad 1600 F with a 150 mm Voigtländer Apo-Lanthar on bellows.

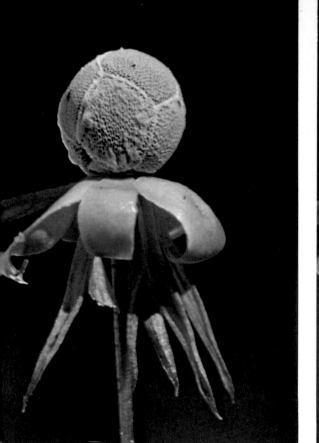

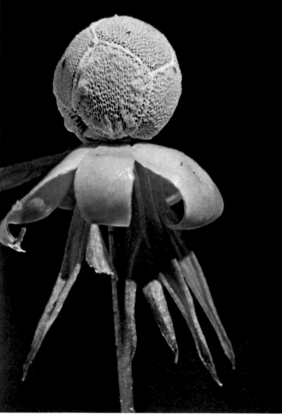

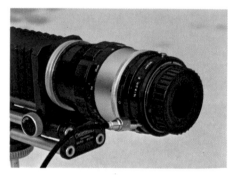

When the Micro-Nikkor is reversed, an E2 ring can be attached to the rear mount of the lens. This makes it possible to open up and close down the lens with the aid of a cable release, thus providing you with a semi-automatic diaphragm control. The E2 ring also serves as a lens hood, here improved by the attachment of a rear lens cap in which a suitably sized hole has been made.

Macrophotography

A fully extended bellows (Novoflex Auto-bellows, approx. extension 14 cm) with a reversed 55 mm Micro-Nikkor was needed to take the honeycombed tennis ball fruit (2.7 mm in diameter). For magnifications greater than 1:1, all lenses gain in sharpness by being reversed (except for some lenses which are specially computed for photography in this range). Here, the reversing of the lens gave an extra 55 mm extension, due to the built-in sunshade. The lens was set to the closest focus (24 cm). Total extension: 25 cm = × 3.5 magnification. Depth of field about ½ mm (!) at f/22. This is as close as one can get in practical fieldwork. Working with two bellows connected or one bellows attachment and several extension tubes is an unmanageable arrangement. The left-hand picture was taken with the mirror 'working': its vibrations blurred the picture slightly. The mirror was locked up before the right-hand picture was taken. This lens appears to retain most of its sharpness even when stopped right down. With a 25 cm extension, f/22 is in fact f/100! The light source was sun from the right. A book was used as a reflector to the left to lighten up the shadows. (Macrophotography: see p. 100.)

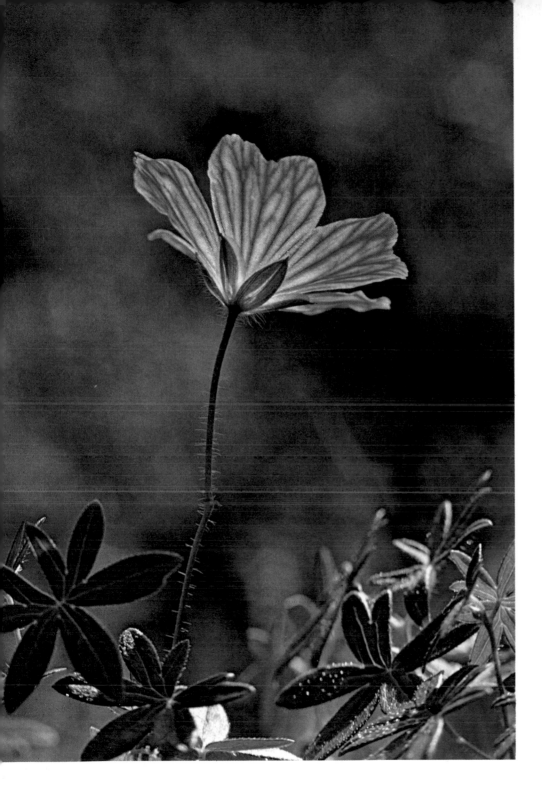

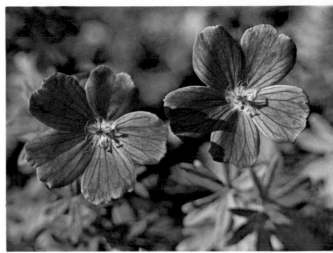

Side lighting and back lighting

The side lighting on the bloody cranesbills (above) makes a biologically informative picture but that is all. The background is disturbing because of the sunlight and the high viewpoint. Nikon F, 105 mm Nikkor, extension tubes, Kodachrome II.

Selecting a low viewpoint one increases the background to subject distance so it will be more out of focus and thereby even in tone, and darker because the shaded sides are facing the camera. The flower stands out in contrast.

When photographing back lit subjects try to stop superfluous light reaching the front lens. Had I not shaded the camera, the sunlight would have hit the inside of the lens hood or even the front lens, adding an unwanted flare to the picture. Use tripod and cable release so you can sit slightly in front and to one side of the camera and control stray light.

51

Nikkor 200 mm with standard lens hood.

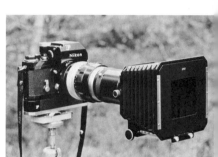

Nikkor 200 mm with the Hasselblad professional lens hood fully extended and the 250 mask.

Without a lens hood, even the light from an overcast sky will produce a flare in the dark areas of a picture.

Nikkor 200 mm with standard lens hood. Full aperture.

Same lens, same aperture, but with a professional bellows-type lens hood.

Lens hoods

Every lens should have a lens hood. (In the US these are called 'shades'.) This hood must be as deep as possible, without vignetting the picture corners even at ∞. The most effective lens hood is the compendium, a bellows which can be extended and fitted with masks to suit the lens being used. I have had an adapter ring made for the Hasselblad professional lens shade or hood, so that it can also be used with Nikon lenses from 35 mm and upwards. With this ar-

rangement I can then use Hasselblad's complete range of filters, close-up lenses, etc. One drawback to compendia is that they are always cumbersome and fragile. One of their great advantages is that they usually have a gelatine filter slit immediately in front of the lens (see picture on p. 26). Compared with glass filters, the range of gelatine filters is enormous. They require careful handling, but the difference in price can be quite considerable. Kodak supply two cheap lens hoods and gelatine filter holders combined: no. 1 for the 20-50 mm diameter range, and no. 2 for diameters between 37 and 70 mm.

Do not let the sunlight reach the inside of the lens hood.

Depth of field

The relation between depth of field and different focal lengths is a topic which causes some confusion. Depth of field is determined by the the *'absolute size'* (aperture) in mm of the diaphragm; not by the f-number on the lens, which denotes the size of the aperture in relation to focal length, i.e., *'relative aperture'*. Thus f/11 on a telephoto lens with a focal length of 200 mm means that the aperture is 18.2 mm, but on a 20 mm wide-angle lens it is only 1.82 at the same f-number. For the same depth of field with the 200 mm lens, you must stop down to f/110! Telephoto lenses cannot be stopped down to the same small apertures (*absolute size*) as wide-angle lenses. Light travels in waves, so f/110 on a 200 mm lens would result in a loss of definition. Short focal lengths then, should be chosen for maximum depth of field and long focal lengths for the greatest possible blurring in front of and behind the main subject.

Increased depth of field

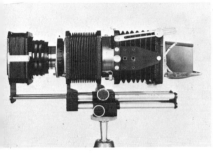

The Hasselblad focusing screen adapter in combination with the magnifying hood is used for focusing. This picture shows the back in neutral position.

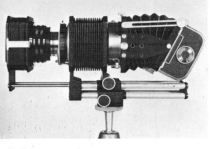

Here the back is tilted and the focusing screen has been replaced with the film magazine. The leaf shutter is triggered with a cable release.

There are other ways of improving depth of field when stopping down is not enough. In 1956 I designed a 'tiltable back' for the 6 × 6 format which opens up some of the possibilities reserved for large format cameras. I combined a Hasselblad bellows (for 1000-1600F) with a 150 mm leaf shutter Voigtländer Apo-Lanthar lens, using two aluminium 'ends' and a bellows in between. The rear end can be tilted backwards or forwards and locked in the required position. It can take the Hasselblad focusing screen adapter as well as the film magazines. This combination works as an independent camera (with continuous focusing from infinity down to life-size). With a back tilt one can put the focal plane along the ground, bringing both the nearest and the most distant objects in focus without stopping down the lens. But one mostly has to use small apertures because of the variations in level. If sharpness is wanted up along the verticals, then the only way is to stop down the lens as much as possible.

Wood anemones and hazel, taken with the 150 mm Apo-Lanthar and the tiltable back.

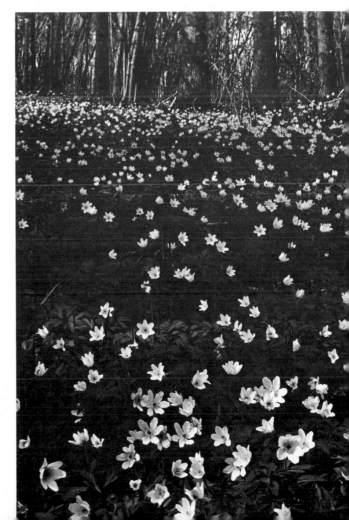

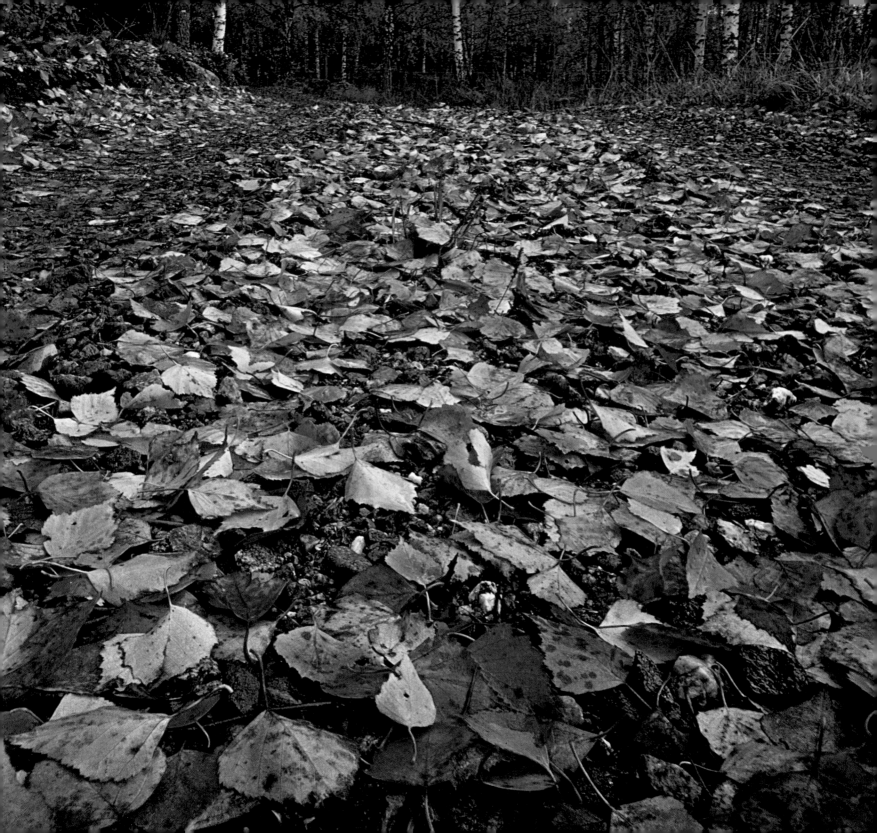

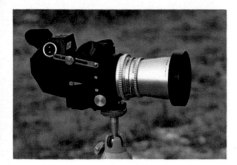

The new tiltable back, with a 50 mm Distagon and the meter prism finder.

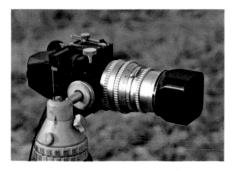

The back, this time with a 150 mm Sonnar turned for focus in the vertical plane.

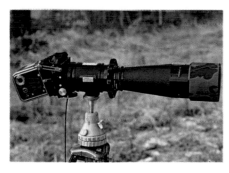

The back, this time with a 500 mm Tele-Tessar and the 70 mm magazine.

These birch leaves were taken with a 50 mm Distagon at f/16. The back was tilted about half way. Agfachrome 50S.

Tiltable back for the 500C

In 1974 I had the tiltable back reconstructed to fit the Hasselblad 500C which increased the possibilities. All the lenses in the system have built-in leaf shutters and can not therefore be used with the new tiltable back (except for the SWC). The problem was that the distance between the ends had to be reduced in order for an infinity focusing to be possible. Owing to the rigidity of the bellows the 'movements' of the back would then have been restricted.

I therefore replaced the bellows with a 'bag' of black PVC resembling the wide-angle bellows of the large format cameras, with the result that the back can now be tilted even further than before. The lens mount, with the device for cocking the shutter and the cable release socket, was taken from the 500C bellows attachment. The winding crank on the magazine is used for advancing the film. By turning the camera to one side (see picture) one can obtain an optional vertical focal plane instead of a horizontal one. At right are examples. The top picture of great reedmace was taken with the back in the neutral position: there was little depth of field, despite the aperture of f/16. The lower picture was taken with the back swung round the vertical axis and the focus trained on a line of 'cigars' — still at f/16. I could have opened to full aperture for this picture, if I had wanted to obliterate details on either side in order to make the 'cigars' stand out in isolation. Focal length 150 mm.

Plant portraits using the tiltable back

The 'selective focus' afforded by the tiltable back is also useful for close-up purposes (see above). The left-hand picture was taken using a 'rigid' Hasselblad, at a slight angle from above to show the glomerule. I had to sacrifice the sharpness of the stalk and the lower leaves, because a small aperture would have thrown the background into undesirable sharpness. The right-hand picture was taken a week later with the tiltable back and the same 150 mm lens. Despite the much higher camera viewpoint — chosen to bring out the glomerules — the stalk has been brought into focus by tilting the back *forwards*. The aperture was f/11.

The Canon TS 35 mm tilted to its maximum angle of 8° (photo: Goran Hansson/N) allows a shift of 11 mm. The Varioflex can be tilted and shifted further than the Canon TS as its focal length is greater, giving a wider image field diameter.

Varioflex on Nikon F. This combination is not as good since the TTL prism finder restricts the shift movements. Other finders can be used, however.

Tiltable lenses

Something of the same depth of field effect can be obtained by tilting the lens, but in this case one is limited by the maximum image size of which the lens is capable. Ordinary lenses do not give the photographer a very wide margin to draw on, but a very different situation applies if you have lenses that are calculated for large format cameras. For instance, a 150 mm Symmar (for the 9×12 format) has a maximum image field diameter of 210 mm at f/16 and ∞.

There are only two tiltable lenses on the market. One is the 35 mm Canon TS. Apart from shifting to correct distortion, this lens can also be tilted 8° at the turn of a knob. A similar device is incorporated by the Austrian Varioflex, which can be adapted to various 35 mm cameras with interchangeable lenses. The lens is a Schneider Angulon 65 mm with an aperture of 1:6.8.

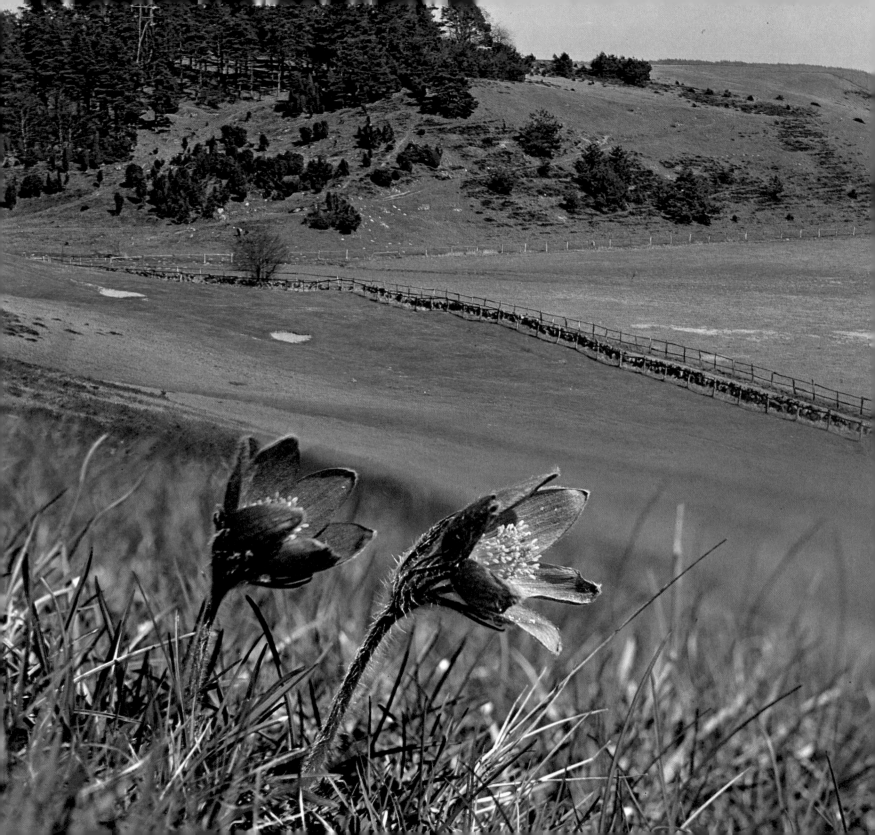

Bifocal lens from Trans World Trading, on a 250 mm Sonnar. Shown here in the horizontal position.

The mounting permits rotation of the lens. Here the bifocal lens is set for a vertical foreground, seen to the left in the picture.

Bifocal lenses

By far the cheapest way of giving one's pictures an unusual distribution of focus is to mount a bifocal lens in front of the camera lens. The one I have used is actually a close-up lens which has been cut in half. This gives a picture with two areas of focus. The furthest away is determined by the focusing of the camera lens while the other is determined by the power of the bifocal lens combined with the focal length of the camera lens and (to a lesser extent) the focusing. A lens of this kind makes it possible to get a detailed close-up of a flower with the environment in perfect focus, but the degree of background sharpness is optional. The picture on the opposite page was taken using a Hasselblad 500C with a 135 mm S-Planar, focused (more or less) on ∞. An aperture of f/22 was used to reduce the blurred area which one gets at the cut edge of the close-up lens. A wider aperture would have made the uppermost petals of the flowers uncannily transparent. One advantage of this method is that the immediate background of the flowers is blurred, which makes them stand out clearly. The mount should be of such a kind that the bifocal lens can be rotated in it.

View cameras

Some passing reference should be made to large format cameras. Obviously these cameras present unique opportunities when it comes to depth of field, restitution and all possible adjustments, especially if they are of the monorail type such as the Cambo and Sinar P in the picture on the left. Both the front (with the lens) and the back (with the ground focusing screen) can usually be rotated and displaced in all planes and directions. The only limiting factors are the image field diameters of the lenses and the limited flexibility of the bellows.

Lingonberries in the south of Lapland. Sinar P 9 × 12 cm with 150 mm Symmar. Agfachrome 50S. The back was tilted backwards and turned slightly anticlockwise round the vertical axis. Despite a high f-number, not even this kind of camera can quite manage the sharpness of a high vertical in the foreound, such as the pine trunk top right.

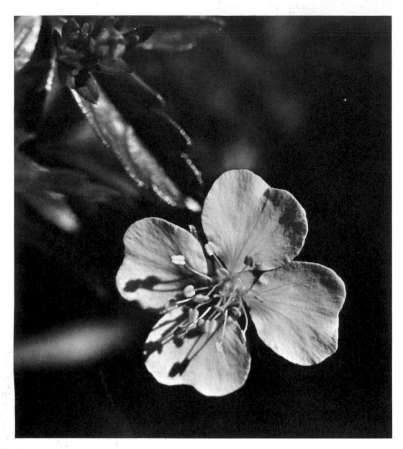

Common tormentil, taken without a filter. Sunlight.

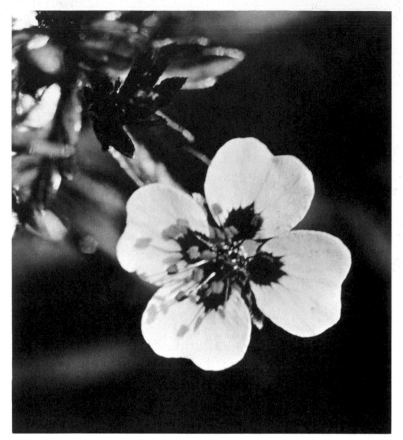

The same flower taken through the UG 1 filter. The base of each petal comes out black because it does not reflect the ultraviolet radiation of the sun. Be careful about the difference in focus, because ordinary lenses are not corrected for the ultraviolet wavelengths. Here (Hasselblad 500C with an 80 mm Planar), the bellows had to be retracted 1.5 mm.

Flowers in ultraviolet light—as insects see them

We tend to believe that the only true picture of reality is that which we see with our own eyes, but scientists have shown that animals have very different perceptions of the world around them. Bees can see ultraviolet lights which enables them to gauge the position of the sun even when the sky is overcast, and to navigate accordingly. To bees, flowers like tormentil, which we see as yellow, present a clear contrast between the light edges of their petals and the centre where the nectar is. These parts look darker to a bee because they do not reflect ultraviolet light. With the aid of the camera, we can capture some of the bee's visual impressions either by using a light source which emits ultraviolet radiation or, in sunlight, by using a filter which absorbs all other wavelengths.

The filter is sold by Zeiss and is very cheap. Designated UG 1, this filter looks completely black to the naked eye. Exposure increase about 12 stops.

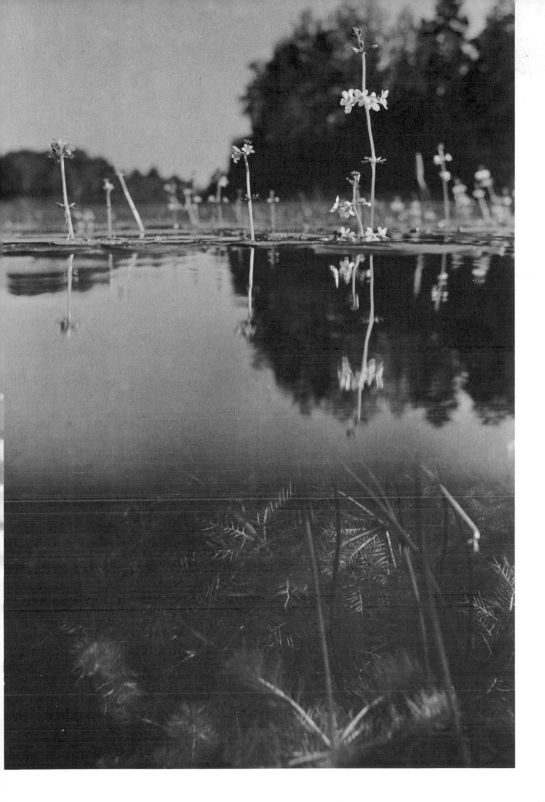

Just below the surface

Underwater photography requires both money and diving instruction. If you only need to get a few decimetres below the surface, you can simply cut a rectangular hole in one side of a plastic tub and glaze it with plate glass. Seal with aquarium putty and four strips of aluminium secured by screws at four-centimetre intervals. There is room for a flash unit beside the camera, but the flash was not used for the picture (left) of the water violets, because the lake was eutrophic and turbid. The flash would have made a 'snowstorm' of all the small particles suspended in the water. It is impossible to make the parts above the surface and those below the surface come together, because air and water refract the light differently. The camera can also be held completely below the surface of the water. If it is aimed downwards and if the water is clear, one can photograph down to several metres below the surface.

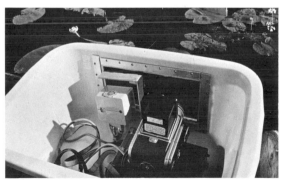

This glorified tub can be used with any SLR camera, so long as you can look into the viewfinder from above. It is often a good idea for the flash unit to be screwed into the edge of the tub and aimed down into the water. The camera lens hood must be held tightly against the glass window and at right angles to it, to avoid reflections and give the best possible sharpness.

Water lobelia seen in shallow water. 150 mm Sonnar, no filter. The same, with a Pola filter. Agfachrome 50S.

The polarizing filter provides one means of 'optically' penetrating below the surface of the water. Water presents a non-metallic surface, so the polarized reflections from that surface can be almost extinguished with a polarizing filter, which is most effective when the camera is held at an agle of 37° to the water. One cannot get this angle over the whole picture. In the right-hand close-up, the effect of the filter was greatest in the top half of the picture. If the water reflects dark subjects instead of a bright sky, a filter can be eliminated. The filter produced no extra effect in the top-right corner of this picture.

Blue—infra-red

Some blue flowers never reproduce accurately on colour film, because they reflect infra-red light, which is visible to the film. Recently colour films have become more attuned to the colour sensitivity of the human eye; see the cornflower series. The only distinct tendency towards red occurred with the combination of Kodachrome II and flashlighting. Agfachrome 50S came midway between Kodachrome and Ektachrome in terms of colour reproduction.

Monk's hood. Agfacolor CT 18 (taken in 1966).

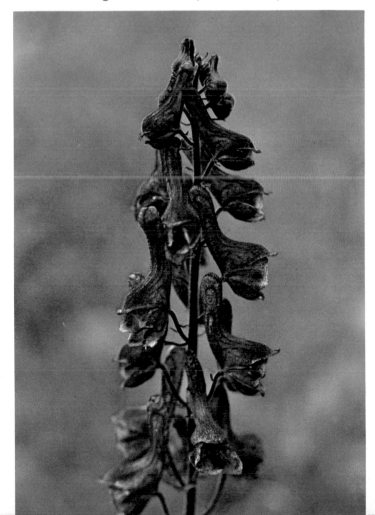

Cornflower
(1974)
Kodachrome II
Overcast

Kodachrome II
Ring flash

Ektachrome-X
Overcast

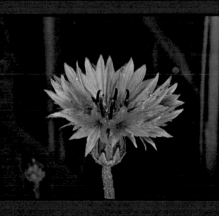

Ektachrome-X
Ring flash

Tripods for plant photography

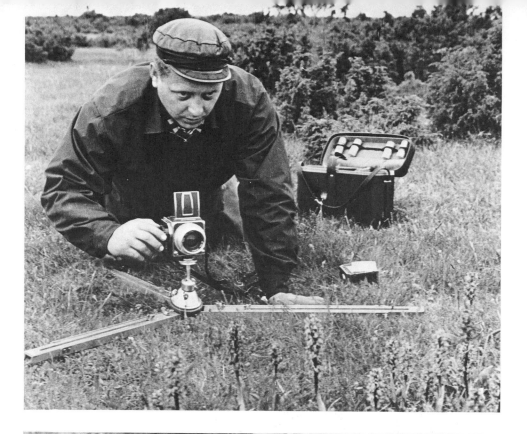

The plant photographer spends most of his working time within half a metre or so of ground level. There do not seem to be any modern tripods that are suitable for this kind of working position. I myself use a wooden tripod like the one in this picture (mod. 19 SZ, weight 1.2 kg). I bought it in 1951, and it is still the lightest and the most versatile of the four tripods in my possession. As can be seen, it has the great advantage of being able to 'to do the splits'. Raising the camera a decimetre or two above this level is more difficult; I have to prop it up from underneath the tripod. (Quick mounts: see p. 107.)

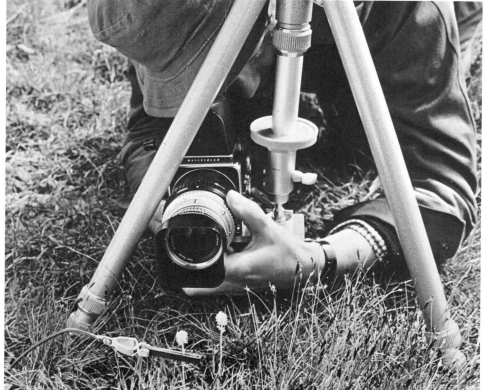

A tripod with a reversible centre post is one solution to this problem, but there is far too little working space between the legs. In order to work with a modicum of comfort, one has to use a plate like the one in this picture and then use either an angle finder or a focusing hood. A 45° prism finder also does very well. The centre post system is far too liable to set up vibrations, owing to the great distance between the camera and the tripod spikes. The tripod shown here is a Gitzo Reporter.

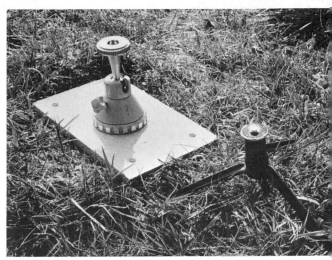

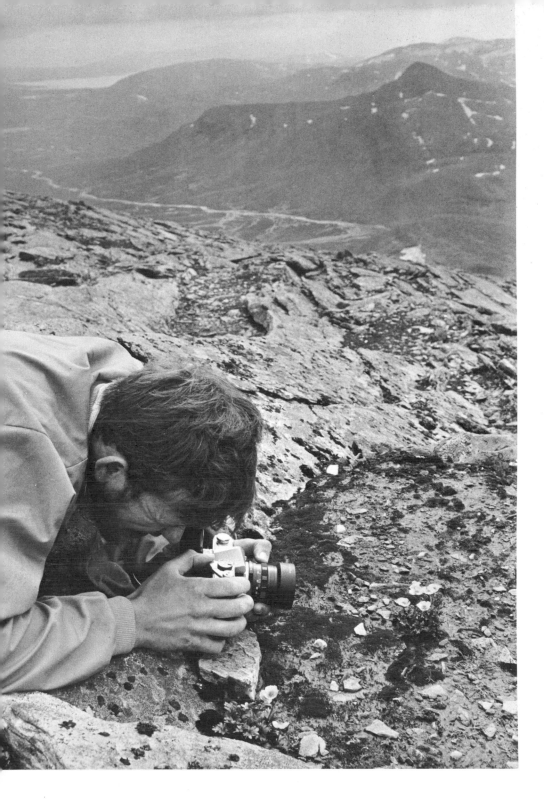

The tabletop tripod (above right, Leitz) is another means of getting down to earth, but it is too small and unsteady, unless the legs are weighted with stones. If the ground is not too rough, a wooden board with a stout nail in each corner can be used. This can be put at an angle if required, so the ball joint is not always necessary.

Plants that grow really close to the ground, on bare mountains for example, can often be taken without a tripod. Lying on the ground propped on your elbows, you can manage a 1/15 sec. exposure or even longer, if you have a steady hand. Often you can easily shore up the camera with gear or stones, in which case you need not hold it at all: this eliminates one potential cause of camera shake. In the left-hand picture, glacier crow-foot is being photographed on the south face of Jeknafo mountain in Swedish Lapland. The photographer has put a right-angle finder on the eyepiece of his camera.

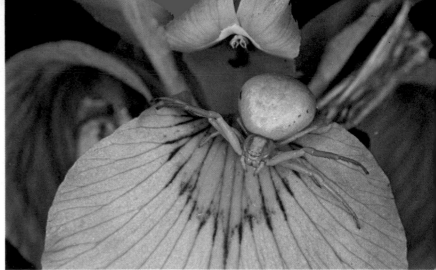

Cowslip: the left-hand one with a short pistil and stamens close to the throat of the corolla, and the right-hand specimen with a long pistil and the stamens further down. This arrangement guarantees cross-fertilization. The sections were prepared with a razor blade. Black velvet provided a completely black and shadow-free background. Daylight.

The photographer who specializes in studying all the tiny animals connected with plant life will never run out of work. This picture shows the crab spider, *Misumena vatia*, which in two days can change colour from yellow, when visiting a yellow flag or a dandelion, to the white of cow parsley. Because of this camouflage, insects coming to pollinate the flower do not notice the marauder — until it is too late. Ring flash.

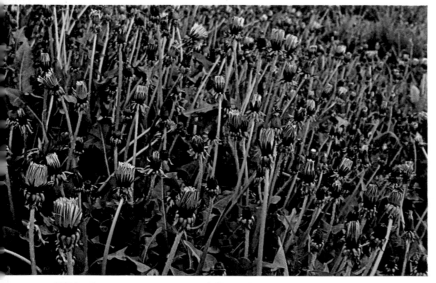

With the camera one can follow the daily rhythm of plant life. This picture, taken with evening drawing in, shows the dandelions closing their petals to shield their stamens and pollen from moisture and dew during the night.

Or again, the camera can follow the seasons. The first dandelion leaves to appear after the thaw are more red than green because of the time required for the chlorophyll to form and outshine the other pigments in the plant.

The variety of shapes to be found in nature is endless. This picture shows the seeds of the small pasque flower from beneath. Hasselblad 1600F with an 80 mm Tessar. An electronic flash gives the dark background needed to bring out all the fine hairs. The contrast can be further increased by placing the flash behind the subject.

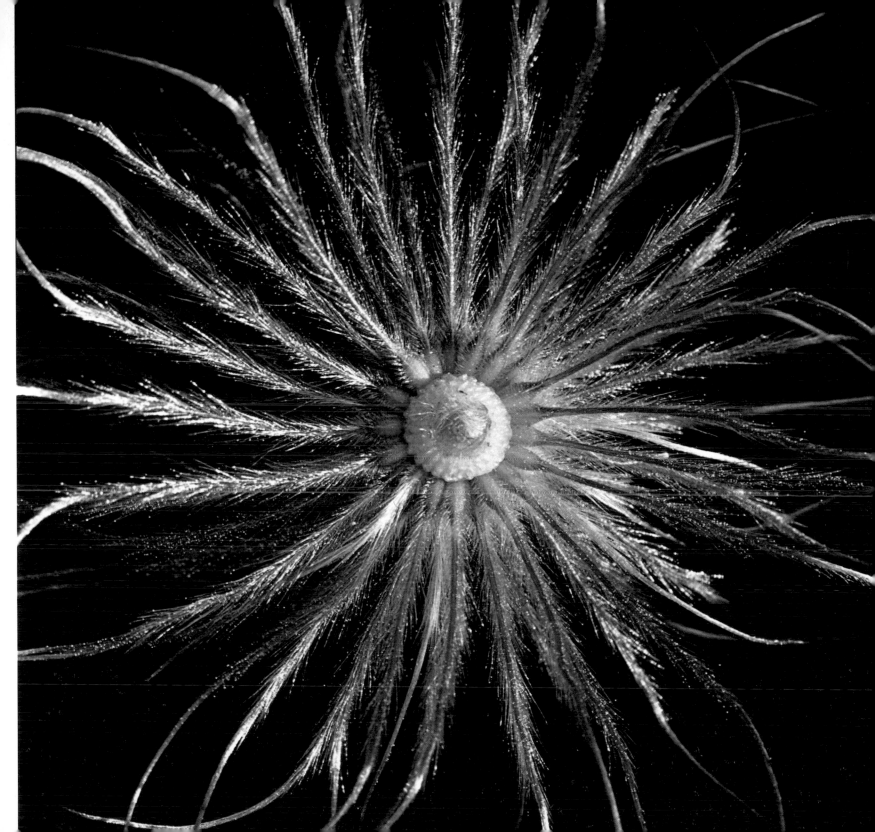

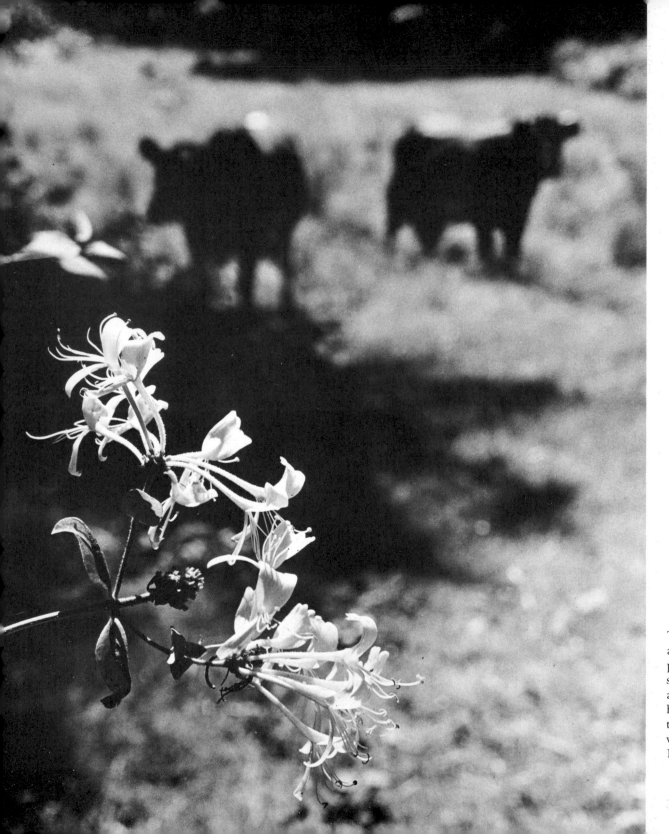

The plant environment can also include these cows at pasture in the oak woods of southern Sweden, which is also the home of the honeysuckle. This particular type of environment is vanishing fast. Hasselblad 1000F with an 80 mm Tessar.

Reflections

Close-ups of fruit, etc. sometimes have to be taken indoors. This calls for artificial lighting. Ring flash is recommended for close-ups because it gives shadow-free lighting, but it is not universal lighting. A shiny fruit will display an irritating ring-shaped reflection. The softest light is got by building the subject into a 'tent' of opaque material. Here I used opal film (Mimosa) which I de-emulsified by fixing and rinsing it. The light was aimed at the 'tent' from the outside, and even with only *one* lamp I got the soft effect into the picture, bottom left. Plastic mugs can be used as small scale 'tents'. Do not use coloured materials with colour film. Even 'white' plastic can colour the light enough to require filter correction.

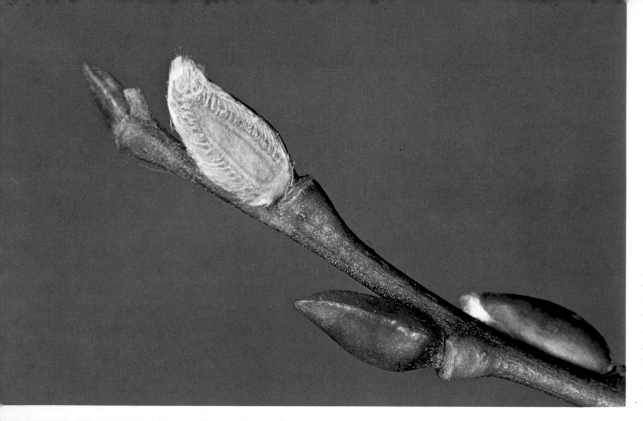

A sallow twig taken in wintertime with one bud cut through in order to show how well-prepared the various parts of the flower are for the coming spring. This picture was taken with the ring flash mounted on the lens. Result: a flat light in which the light parts facing the camera easily get overexposed.

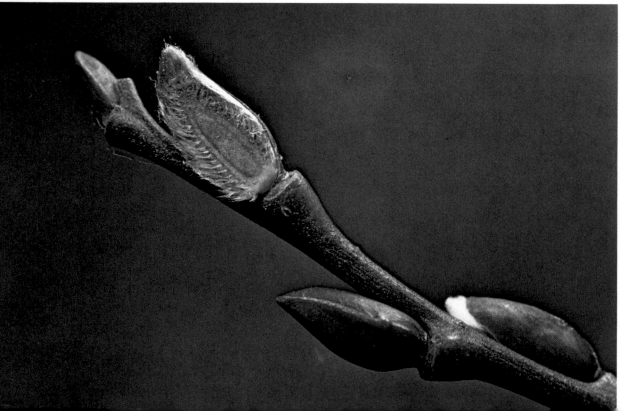

By holding the flash in front of and above the twig, one obtains a light which brings out the details more clearly and gives more natural shadow. This picture was taken indoors against a cardboard background, using a Nikon F with a 55 mm Micro-Nikkor. Kodachrome II. Minicam ring flash and Braun F800.

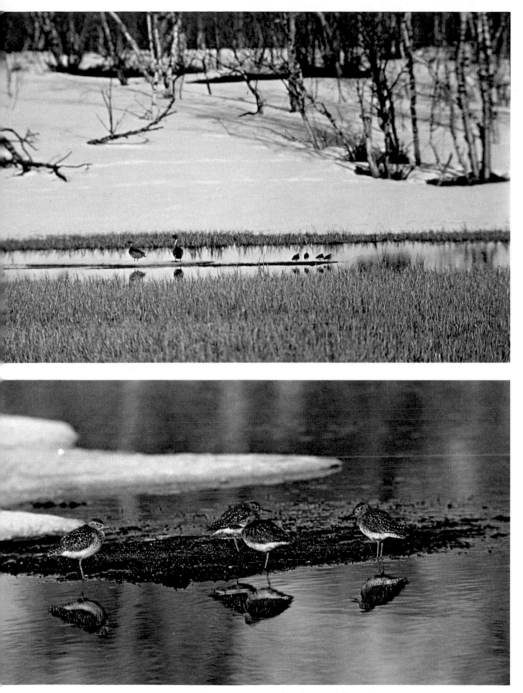

These pintails and wood sandpipers were taken with a Pentax SP, a 400 mm Noflexar and Agfacolor CT 18.

Animals

Photographing the big vertebrates means getting within range of them. Flight from an approaching enemy — you — is an instinctive reaction in all animals. But the distance at which they take flight varies a great deal depending on their physical condition and, not least, their previous experience of human beings. In the two pictures on this page one sees how the two pintails, belonging as they do to the family of duck which is assiduously hunted, crane their necks while the photographer is still about 40 metres away — a second later they were on the wing — while the wood sandpipers remained quite unperturbed, with their heads retracted, even when the photographer was less than 10 metres away. Part of the reason why the sandpipers let me come so close must have been that they had just come to Lapland and were tired after their long journey. Also, small birds are usually less shy than big ones. Inexperience of human beings is reflected by a striking lack of fear on the part of birds in the Arctic and the Antarctic. Birds which breed in colonies are sometimes quite unafraid of human beings.

Up to a point, the photographer can allay the fears of the animals he approaches — by feigning indifference, by approaching indirectly or by only moving when the animals are looking the other way. Above all, do not stare at them. Look with partly closed eyes; out of the corner of your eye, or else use a camouflage hood (p. 85). It has proved possible to get close up to animals by crawling on knees and elbows: arouse their curiosity instead of frightening them; that is half the battle.

Telephoto lenses

The telephoto lens is indispensable to the animal photographer. For the stalking photographer, a focal length of about 400 mm (for 35 mm cameras) is the best compromise between range and handiness. A very popular lens is the Novoflex, which has a 'pistol grip' incorporating an extraordinarily fast focusing. With fully compressed grip, the lens focuses on infinity. If it is released, a spring ejects the lens to a closest focus of about 8 metres. To get closer still, there is a built-in bellows which, fully extracted, gives a closest focus of about 2 metres. The lens is very simple (two elements), but gives a good sharpness and contrast in the centre. This central sharpness is often sufficient for pictures like this one of the oyster-catcher (right), but the inferior picture quality at the edges is disappointing in photographs of a flight of birds or a landscape.

The Novoflex pistol grip, with a focal length of 400 mm. (The same pistol grip can also be fitted with lenses of 280 or 600 mm focal lens.)

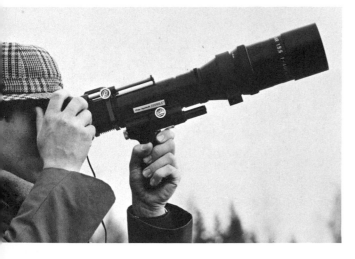

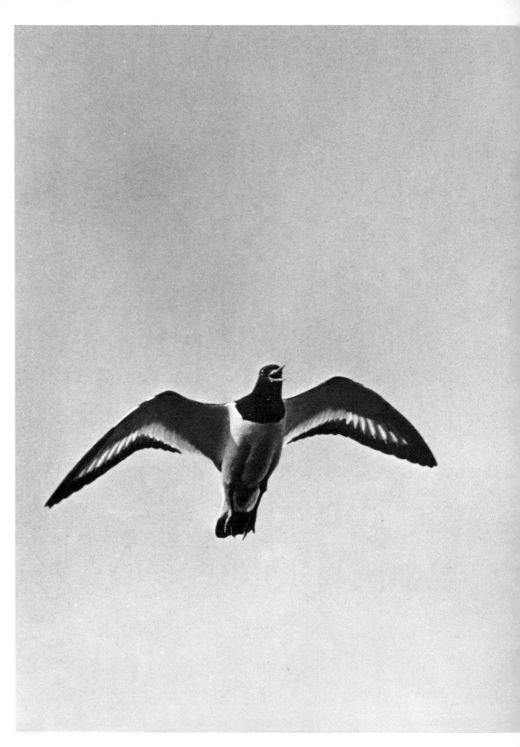

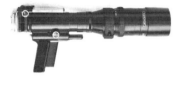

Weights and sizes (top to bottom):
Soligor 6.3/400 mm, 1.1 kg
Novoflex 5.6/400 mm, 1.9 kg
Telyt 5.6/560 mm, 3.3 kg
Reflex-Nikkor 11/1000 mm, 1.9 kg

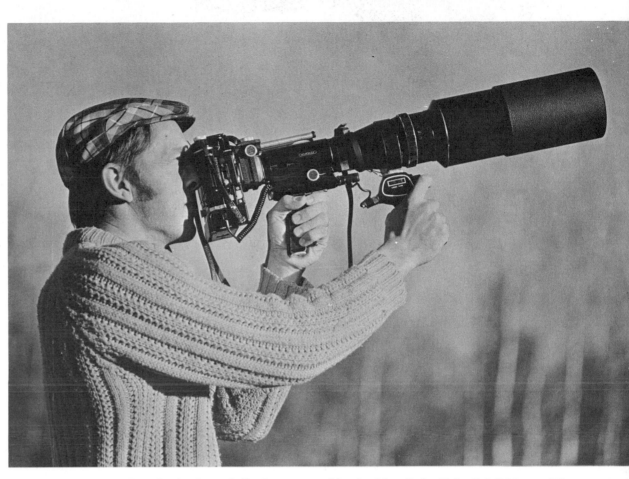

The Novoflex pistol grip and diaphragm combined with a Leitz Telyt 5.6/560mm. The forward handle carries a 'trigger' for the current to the Nikon motor.

To improve the sharpness at the edges, I replaced the lens head with that from a Leitz Telyt 5.6/560 mm. The extra weight necessitated a second handle in front of the first. Combined with an electric trigger for the Nikon motor, this resulted in a fast working unit in relation to the great focal length. But I found the weight (3.3 kg without the camera) and length of this equipment inconvenient, so I use a Soligor 6.3/400 mm weighing 1.1 kg. With this light equipment I can easily keep up with fast-moving animals. The automatic diaphragm helps in strong light, and the focusing is very smooth for the helicoid type. By removing the stop screw for the focusing one gets a closest focus of 2.8 metres. The quick focusing on the Novoflex really is quick, but often one's grip relaxes slightly after the actual focusing, thus bringing the subject out of focus. The helicoid focusing is more smooth and reliable. In combination with a motorized camera it is easier to follow a bird flying towards the camera from one side and obtain a whole series of sharp pictures. In 1975 I exchanged the Soligor for a Nikkor 5.6/400 mm.

73

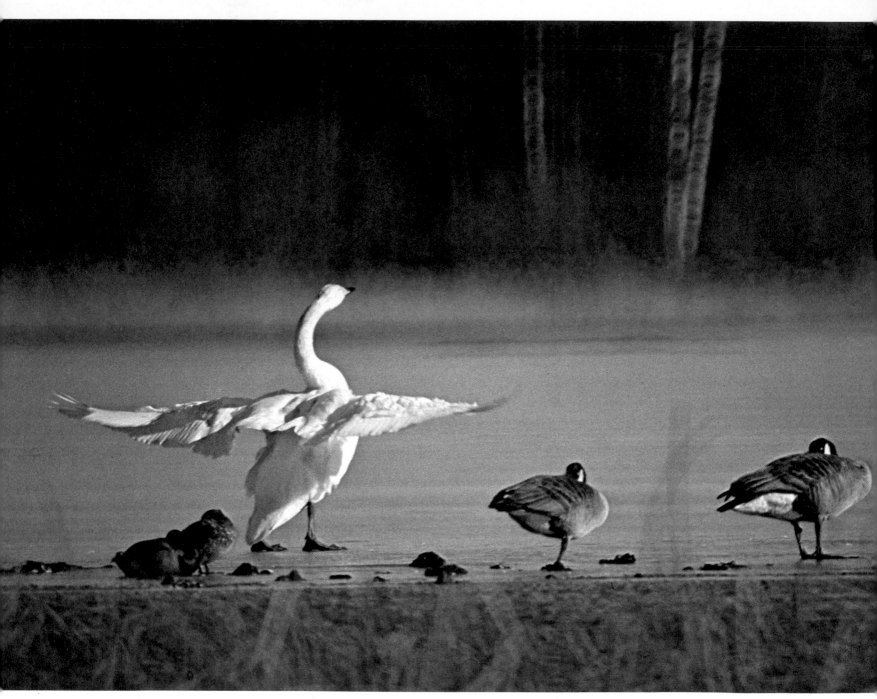

A whooper swan, two Canada geese and a pair of mallard resting by a lake in central
Sweden during their spring migration. Taken from a floating hide (see p. 80) using a Nikon F
with 1000 mm Reflex-Nikkor. Notice the 'ring effect' on the birch trunks in the background.

74

Telephoto lenses more than 400-600 mm in focal length are very awkward to handle. Catadioptric (mirror) lenses are the exception. Because they reflect the light back and forth in a system of mirrors, these lenses are very compact and light (mirrors are thinner than lenses). The 1000 mm Reflex-Nikkor weighs 1.9 kg. Their disadvantage is their aperture ratio, which cannot be controlled as there is no diaphragm, so if the camera shutter cannot be set to 'intermediate' times, one's exposure is liable to be half a stop out. The focusing on the 1000 mm Nikkor is very smooth but critical, because the depth of field is extremely small. The closest focus is 8 metres, and there is no way of getting closer by fitting extension tubes or a bellows attachment. Zoom lenses are subject to the same limitation because one does not focus them by increasing the distance between the camera and the rear group of lenses but by means of other displacements in the optical system. (But one can use close-up lenses on a zoom lens.) Some pictures taken with catadioptric lenses are recognizable by the eye-shaped patches which appear in the blurred area. If this area includes highly luminescent points, such as the water droplets on the birch twigs (picture right) catching the sunlight, the single circles of the ordinary telephoto lens turn into rings, and the further away they are from the centre, the more 'slant-eyed' they become. The 'pupils' are caused by the small mirror in the opening of the lens.

The greater the focal length, the more air there is between the subject and the camera (given the same scale of reproduction). A 1000 mm lens needs clean, dry and calm air to be able to give clear pictures.

A 1000 mm mirror lens may be used without a support at the fastest shutter speeds. Here the camera is motorized and a mouth release is constructed, consisting of two relay contacts in a plastic tube. A non-motorized camera can be fitted with a cable release worked by the mouth. This leaves the hands free to steady the camera and focus. At right is a plastic drain pipe used as a four point support. This way sharp pictures can be taken with a 1000 mm lens at shutter speeds down to 1/15 sec., which is impossible with an ordinary tripod.

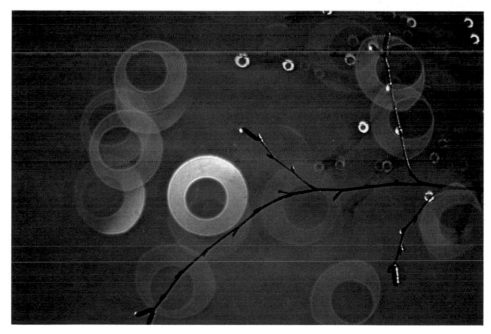

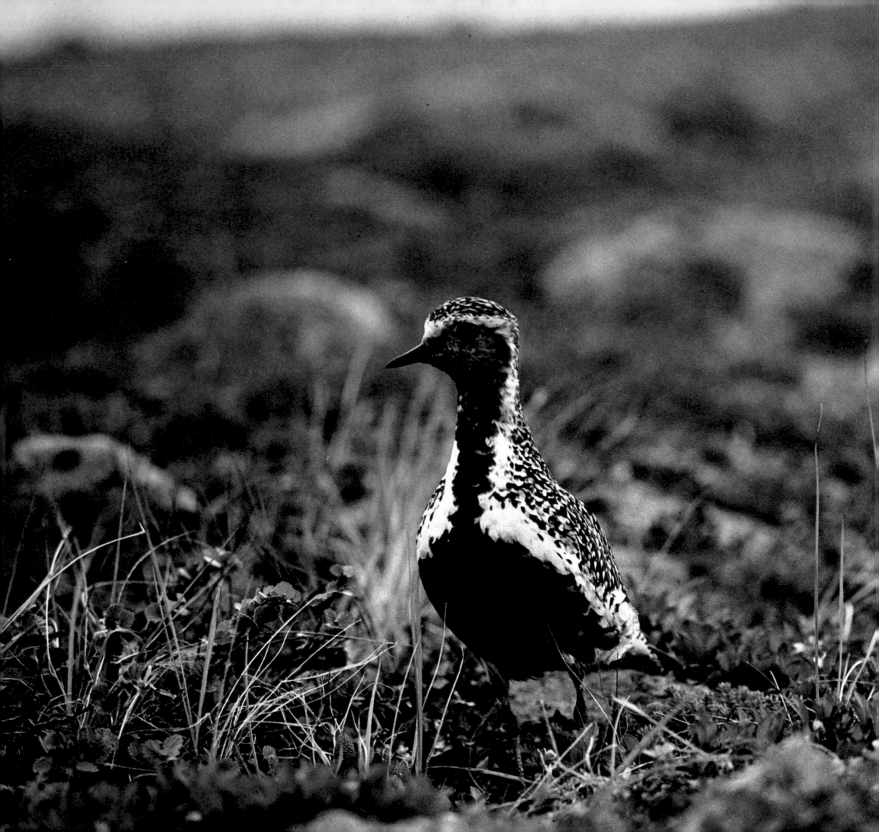

A ground hide camouflaged with dried seaweed to blend with its surroundings.

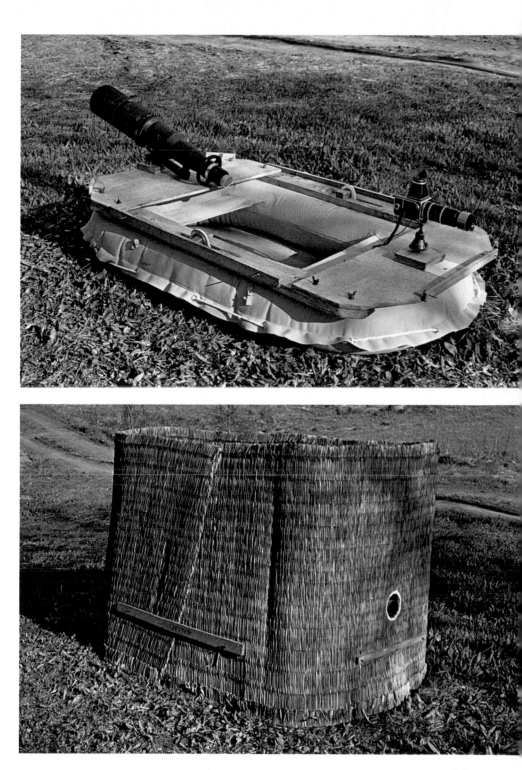

support so that one can look through the viewfinder without too much discomfort. The frame is a few sticks tied together covered with a cloth which has a hole for the lens. Crawl in while a friend covers the hide and you with camouflage. This is a convincing hide and the birds generally come back within minutes of your helper going away. The same type of hide can be used near places where birds feed, or pause during their migration, and offers more interesting pictures than can be taken at the nest. Along the seashore, dry seaweed (above) makes excellent camouflage material. This low camera position brings one down to the bird's own level, so that it stands out above the confusion of the terrain and the background comes further away. The picture of the golden plover at left was made with a Hasselblad 1600F and a 250 mm Sonnar. (Agfacolor CT 18.)

A floating hide can be very useful where the water is not too rough. Top right: an example made from an inflatable rubber dinghy and a dismountable wooden frame. Somebody else in a second boat must put on the camouflaged rush matting.

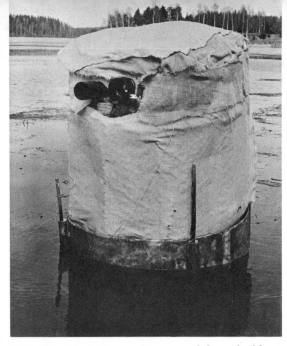

This floating hide can be rotated from inside.

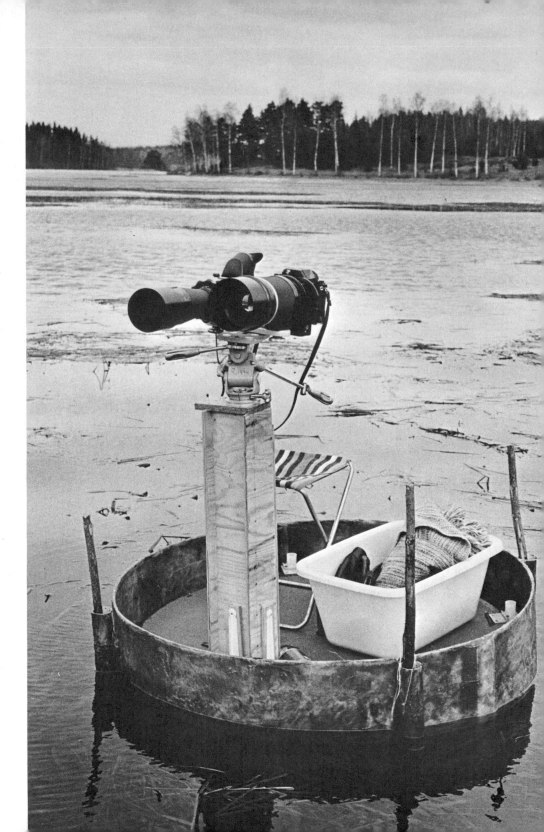

This floating hide is more sophisticated, despite the tatty outside sacking. The base is a round plywood tub, 110 cm across, covered with waterproof glass fibre-reinforced plastic. In the bottom there is a disc mounted on eight rubber wheels running round a central pivot so that the photographer can turn himself and all his equipment, including the outer sacking, through a complete circle without leaving the hide. This is a great advantage at resting places, where the birds may come from any direction. A tripod in the form of a square plywood post economizes on space. The outer tub was anchored to the lake bed with four sticks inside plastic tubes which give enough clearance for the hide to rise and fall with changes in the water level but with as little play as possible, so that the hide will not rock with every movement from inside. (Since the picture was taken, I have replaced the sticks with plastic poles of

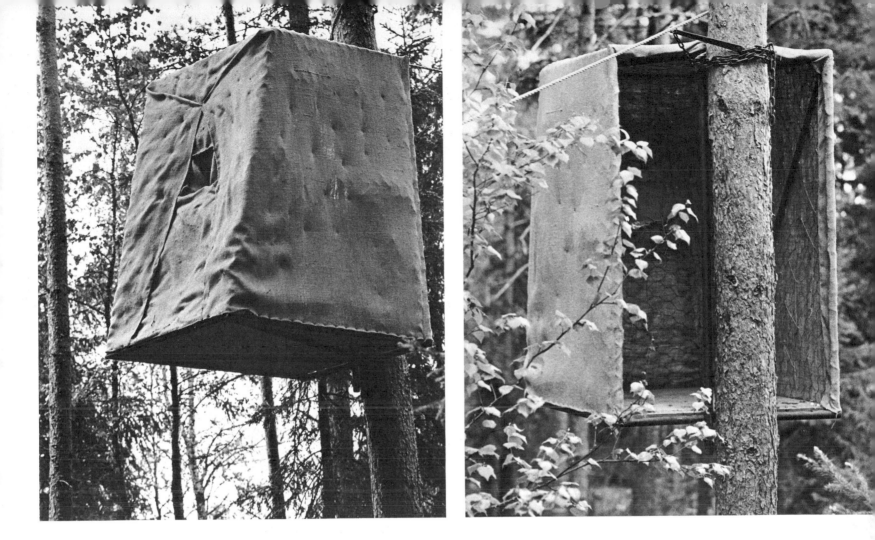

uniform thickness, which are a better fit.) The sacking, stretched over wire netting, is supported by four plastic poles joined at the top. A plastic sheet under the roof keeps moisture from leaking in. The sacking is coarser at eye level, so that I can see through it. If you wear wading trousers, you can wade quite a distance out from the shore of a shallow lake with plenty of vegetation. The trousers contain quite a large volume of air, and you transfer a lot of weight to your very buoyant hide, so it is possible to cross muddy

patches of lake without getting bogged down.

The tree hide above is made of tubular steel covered with jute sacking fastened onto wire netting to hold it still, and fitted with a thick plywood floor. The hide is secured at the top with a chain. A simple block and tackle hoists the hide into the tree. The advantage of a tree hide is that it is high enough to keep your scent away from ground level.

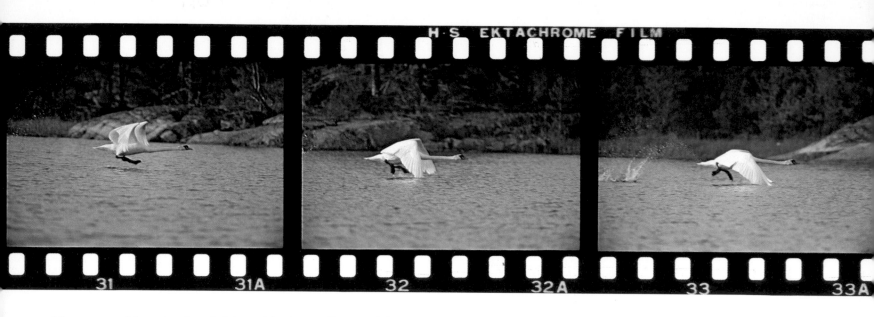

Mute swan taking wing in a Baltic archipelago. Nikon F with 400 mm Soligor. Motor setting 3 exposures per sec. High Speed Ektachrome.

Canoes and motorized cameras

Like the car, a boat is one means of getting closer to animals than would otherwise be possible. Paint the paddles greyish blue, keep them as low as possible and get up full speed while out of flight distance of the animals, so that the canoe can then glide into range under its own power and be inconspicuous. Another way is to let the canoe drift with the wind towards the subject. The Klepper canoe is dismountable and its rudder can be controlled with the feet; this saves exertion and leaves both hands free for the camera. I have a light outboard motor (a 2 HP Yamaha) on my Klepper. It has to be mounted to one side, but it only weighs 9 kg and can be counterbalanced with gear. With a motor I can get even closer to sea birds. Thanks to the absence of movement

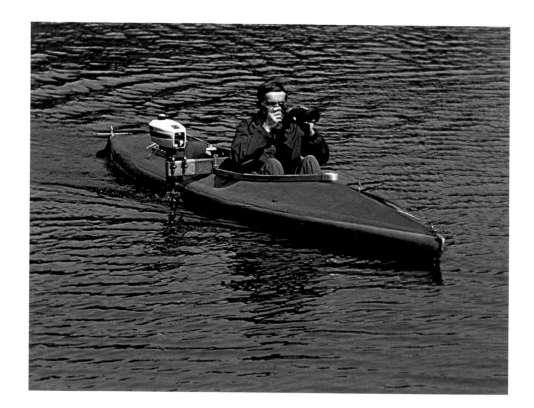

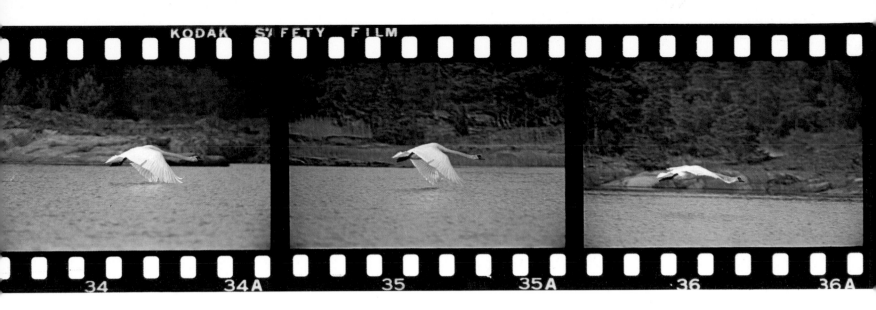

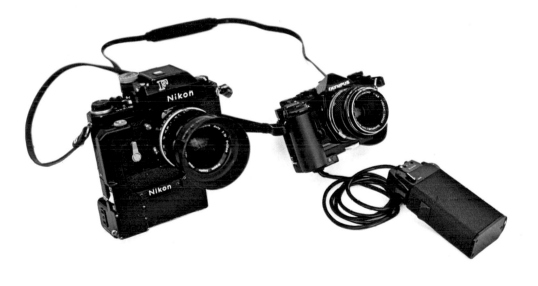

Two different battery arrangements. The Olympus battery handle can either be secured under the motor or kept in a warm inside pocket with flex to the motor. This raises the capacity of the batteries in severe cold.

and the soft noise of the motor at its lowest speed, I can get to within 10 metres. Facial camouflage can help too (p. 85).

The open scenery of a seashore presents superb opportunities to follow birds in flight. With a motorized camera you can get a whole series of pictures from a single passage. The 35 mm motorized cameras are superior, being capable of 4 frames per sec. (some makes are even faster), while the longer, heavier film advance of the medium format cameras takes almost one second per picture. A moving subject which disappears from the viewfinder for that second may be lost altogether; nor is it easy to keep it in focus. If the camera has a mirror of the instant return type, these two disadvantages will be alleviated.

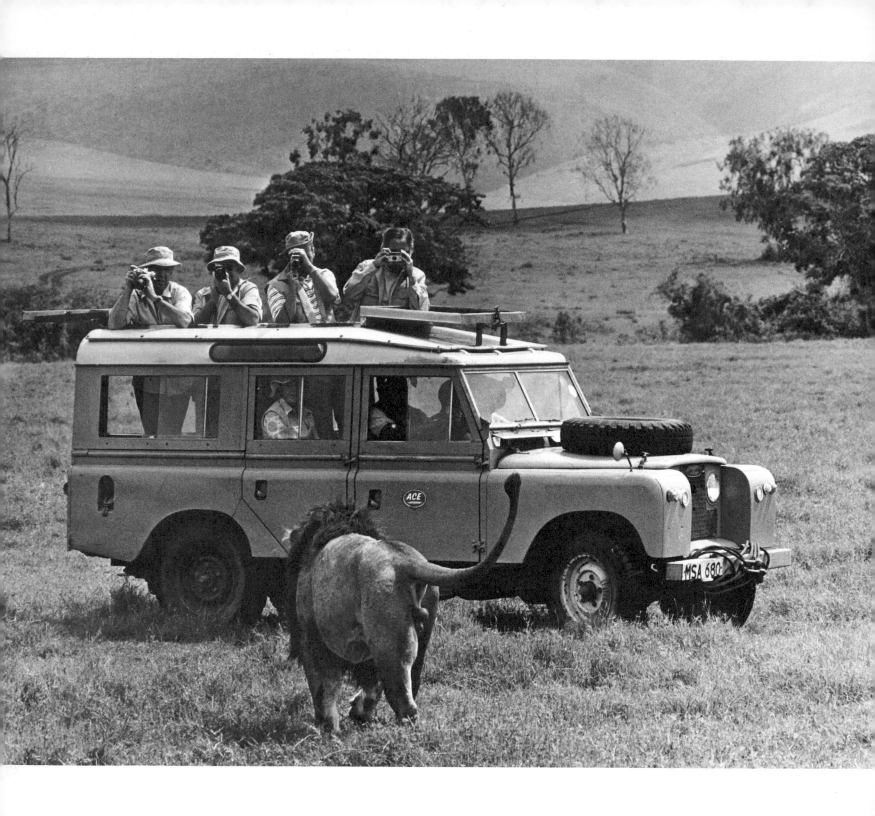

Larger mammals

One photographs the large mammals with much the same equipment as for birds, but remember that, whereas birds are 'ocular animals', mammals rely on hearing and scent. One's strategy should be adapted accordingly. Mammals are mostly photographed from motor vehicles. Not all animals are as indifferent to the presence of cars as this male lion in the Ngorongoro Crater in Tanzania who was on his way to a first class scratching post—the Land Rover. One has to be more careful with rhinos and elephants, which can become aggressive even if a vehicle is 100 metres away from them. Be prepared for individual differences between animals of the same species. Never leave the car, even for the most lethargic looking lion. The result can be unexpected and fatal. The elks of Scandinavia, which are used to human company near the towns, are also to be respected. An over-enterprising photographer had a leg kicked off and was lucky not to have been killed. Know the danger signals. When an elk lays its ears back it is time to run.

When stalking animals, you must approach them from the *leeward* side, moving as inconspicuously as possible. Check with one foot that the space in front of you is quiet before transferring the full weight of your body. Wear cotton and woollen clothing that is quieter than synthetics. Rain and wind conceal many sounds. Use the vegetation as cover and keep still when the animal's attention is focused in your direction.

As shown on this page, much can be accomplished by camouflaging a white face and hands, which, with the erect posture, are the main distinguishing features of the human species. One's clothing must be the right tone. The actual colour is less important, because mammals (apes and monkeys excepted) have an undeveloped sense of colour. This sort of jacket, gloves and camera camouflage tape are sold in sports shops. White overalls are the best camouflage for snow. Camouflage tape can be used to protect the exposed parts of a camera with a view to conserving its second-hand value.

There is usually no danger in looking out of an open window or roof, but the animals' reactions should be carefully observed.

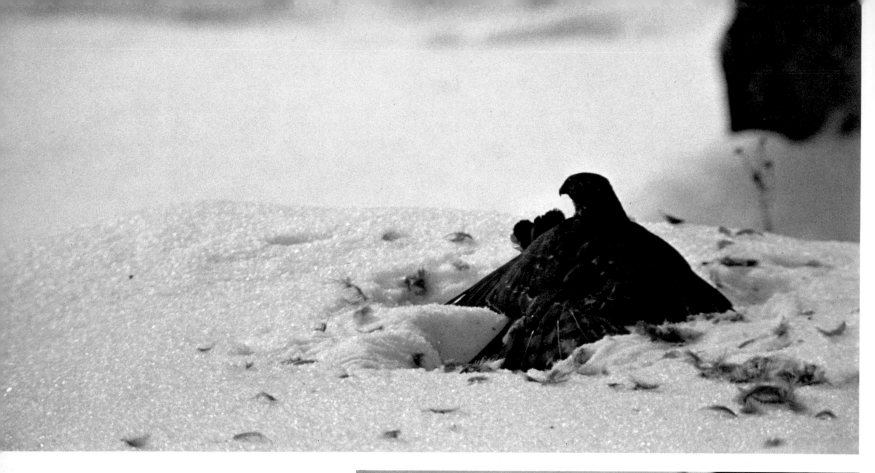

Fast reactions

The secret of success for an animal photographer is to react swiftly. In this case a sparrow hawk had taken a jay right outside my house. One cannot get sharp pictures through a window, so I moved quietly down the steps from the kitchen door, with my camera poised, the exposure set and everything ready. *Very slowly* I eased the lens round the corner. As soon as I took the first picture, the sparrow hawk flew off with its prey, but the Nikon motor was fast enough to get another shot showing the two birds in the air. 1/1000 sec.

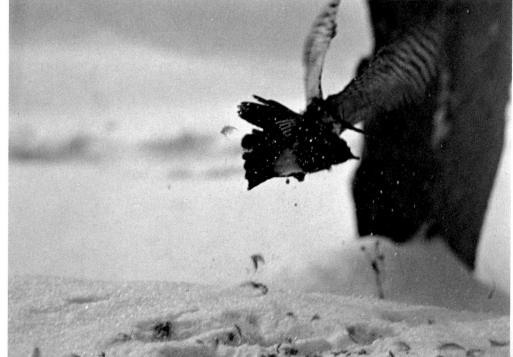

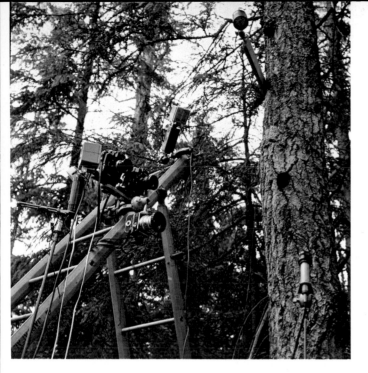

An electric bulb (filtered red to make it invisible to the owl) transmits a light beam to a photo-electric cell. When the owl breaks the beam, this actuates a relay connected to the motorized cameras. The owl's speed needs a flash duration of only 1/5000 sec. Photo-electric cells, as well as electro-magnetic and radio-controlled remote shutter releases, are made by Schiansky in Munich.

Faster still

Photocell release makes it possible to photograph animals which are too fast for our reflexes or whose nocturnal habits prevent us from timing an exposure properly. It is also useful when you cannot sit up watching for the necessary length of time. I have only used a photocell at the nest of a pygmy owl which was not at all put out. It was unnecessary to use a hide. But as a matter of principle, I feel that one should be careful about using a photocell near a nest because the flash, etc. can induce a serious degree of stress on the part of the bird.

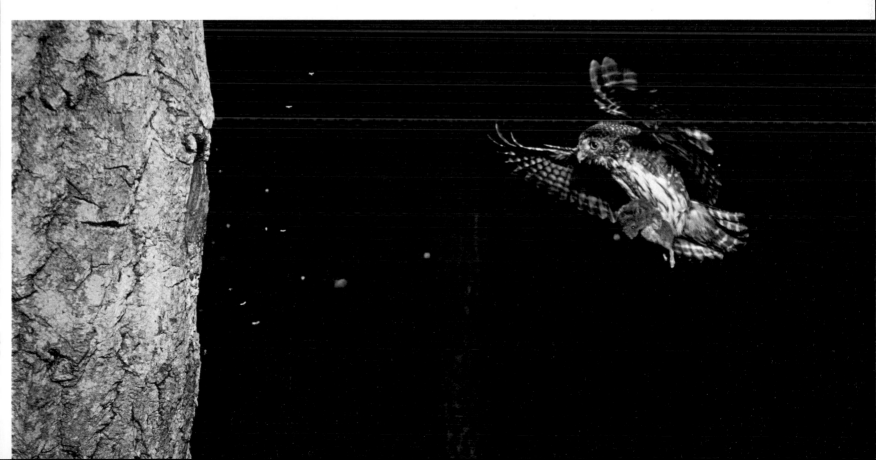

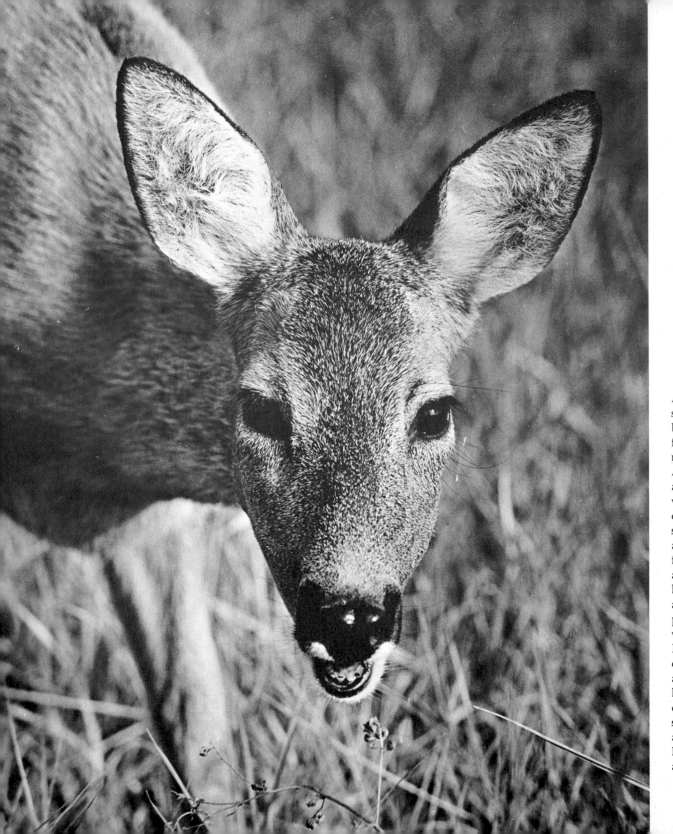

An inquisitive and somewhat irritated roe barks at the photographer from no more than a few metres' distance. Animals are individuals, and their behaviour can vary a good deal. The chances of meetings at such close quarters as this are particularly favourable near towns and cities or on large housing estates where the animals are used to people. Hasselblad 1600F with a 250 mm Sonnar. It is not always extreme close-ups that tell us most about the way animals live. This roe deer is digging through the snow to get at last autumn's rape. Hasselblad 1600F with an 800 mm Telon.

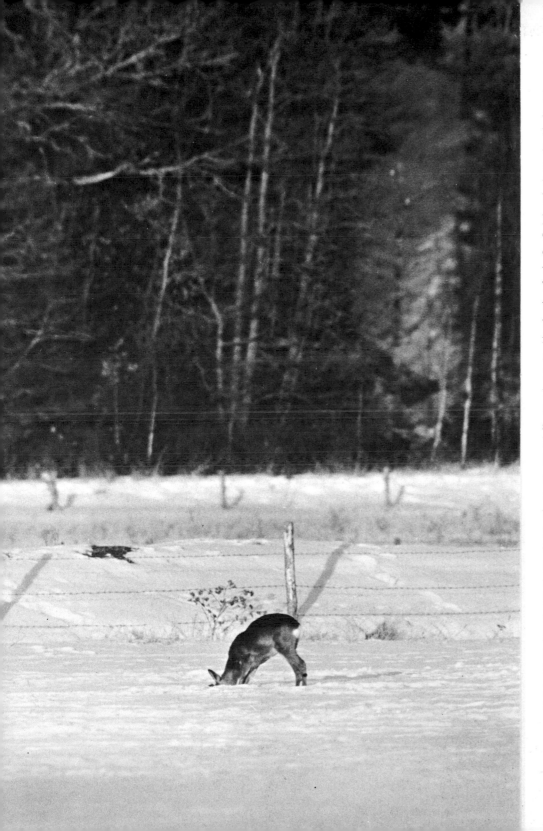

Lures

If you cannot get within range of the animals you may get *them* to come within range of you. Co-operate with gamekeepers and you may be able to arrange feeding grounds. If your quarry is a mammal position yourself at a height, so as not to be betrayed by your scent (p. 81). The feeding places arranged by ornithologists in Scandinavia every winter for the 'detoxification' of the few remaining eagles are usually visited by other birds of prey and by the fox. There are various kinds of animal decoy whistles on sale. The squeaking of a mouse will attract foxes, and the whimpering of a fawn will bring a roe closer. Tape recorders and battery-driven gramophones with recordings of animal calls have also been used as lures. Animals responding to an acoustic lure show less tendency to shy at the sound of a camera. Even olefactory lures have been used. One enthusiast marked a 3oo-metre trail through the forest with turpentine. This attracted a bear all the way to a lonely cabin, where the photographer was lying in wait with his camera. Just as the play-back of a bird song will cause the local occupant of the species in question to approach, determined to oust the intruder, a mirror or even a dummy limited to the most important characteristic can have a similar visual effect, thus providing the photographer with pictures of birds displaying threatening or demonstrative behaviour. One should be careful, however, not to expose animals to undue stress with these unnatural adversaries.

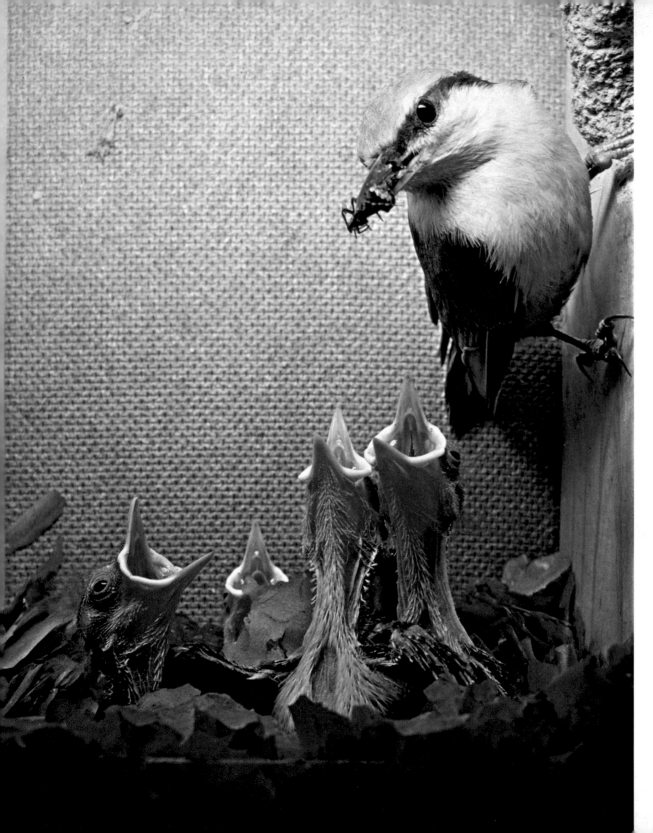

Inside the nesting box

The true bird photographer will want to follow the life of birds in all situations. Even the secret life of the nesting box can be photographed if you detach one side of it and rig up a camera and flash. The three cables in the picture (top), from left to right, are synchro cable, remote release and flash (no reflector, but glass wool fabric in front for soft lighting). The housing for the equipment is held in position by two screw clamps. It should be put up by easy stages, even though garden birds are not frightened of humans. This nuthatch family was taken with a Nikon F and a 35 mm PC-Nikkor on Kodachrome II. It is seldom one uses wide angle for bird photography: notice the increased brilliance resulting from the small quantity of air between the camera and the birds.

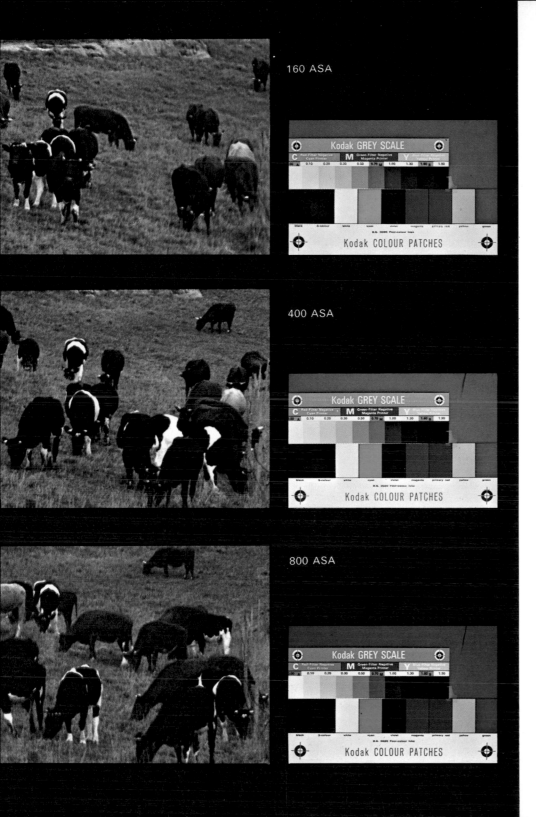

160 ASA

Kodak GREY SCALE

Kodak COLOUR PATCHES

400 ASA

Kodak GREY SCALE

Kodak COLOUR PATCHES

800 ASA

Kodak GREY SCALE

Kodak COLOUR PATCHES

In poor light

Many animals, particularly mammals, are active during the darker hours of the day. There is a limit to the speed of a telephoto lens which is to be used hand-held, and the sensitivity of a film is a compromise between its grain and its other properties. Most nature photographers use 400 ASA film as their standard film for *black and white*. If this is not enough, the film can be 'pushed' 2 or 3 stops, i.e. underexposed and developed for a longer period of time, possibly at an elevated temperature. But the resultant 1600-3200 ASA is obtained at the price of a coarser grain and higher contrast. There are special developers with which film is processed in two baths. Tetenal Emofin is one, and is said to tolerate 2 stops underexposure without any significant increase in grain size. Another answer is the ultra-fast films which give 1600 ASA even when normally developed. These demand exact exposure for the best results, and they cannot be pushed very far.

Colour film can also be pushed in the developing process, and most processing laboratories do this, usually at an extra cost. Colour film reacts differently from monochrome to this operation. The main resultant loss is of basic black: the pictures become more uniform in tone and shadows are rendered brownish instead of black. In the pictures on this page, Ektachrome High Speed (35 mm) was exposed as per 160, 400, and 800 ASA. All three pictures show only a small portion of the originals. If one uses two camera bodies (or magazines), it is a practical arrangement to have, say, a 400 ASA monochrome film in one of them and a colour film of the same rating in the other which saves time in the hurried situations in which the animal photographer finds himself.

91

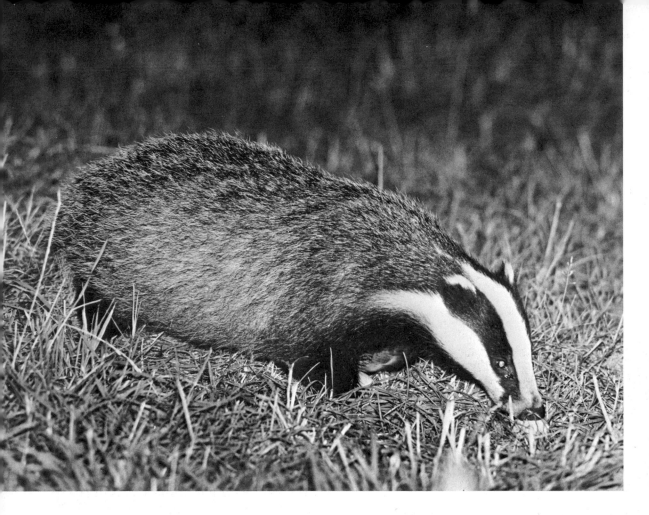

This badger was taken with a Tele-Tessar 500 mm at a distance of about 7 metres. One of the advantages of the telephoto flash is that it gives enough light to the background as well: this picture does not have the all-black background that is usually produced by a flash. Of course, not even the concentrated beam of a telephoto flash will suffice if the background is too far away.

The telephoto flash is mounted on a 500 mm Tele-Tessar, but it can be fitted onto most lenses, because the holder is made from flexible plastic guttering. To illuminate the full format, however, the focal length must be about three times that of the normal lines or longer. The telephoto flash weighs about 1 kg.

Telephoto flash

Flash lighting can be used, of course, when photographing nocturnal animals—if you have a point of reference to help you aim your camera and flash correctly, e.g. the opening of a burrow. Pictures of this kind have been taken ever since animal photography was in its infancy. It is less easy, however, for a photographer to use flash lighting when stalking his quarry, above all because the light diminishes so rapidly in .

proportion to the square of the taking distance. If you can use f/11 at 2 metres, you will need f/5.6 at 4 metres and f/2.8 at 8 metres. One solution is the telephoto flash.

Large Fresnel lenses can be used to concentrate the light from an ordinary electronic flash into a narrow beam. The Fresnel lens has a certain focal length. The focal length of the lens shown in the picture is 29 cm, which means that it has to be placed 29

cm in front of the flash. I have built the Fresnel lens and the flash together with thin aluminium sheeting. The holder underneath is hinged at the back, while in front of the hinge there is a 'fork' to even out parallax at different distances. An opaque plastic sheet or suchlike has to be placed in front of the flash, otherwise an image of the flash tube will be superimposed on your subject.

There is a commercially available telephoto flash: the French Maxiflash, in which a curved mirror serves to collect the light. It is difficult to correct for parallax with the Maxiflash, however.

The telephoto flash can be used for taking distances of 25 metres or more if you are photographing with high speed or 'pushable' monochrome film. One difficulty which should not be underestimated is that of focusing in the dark.

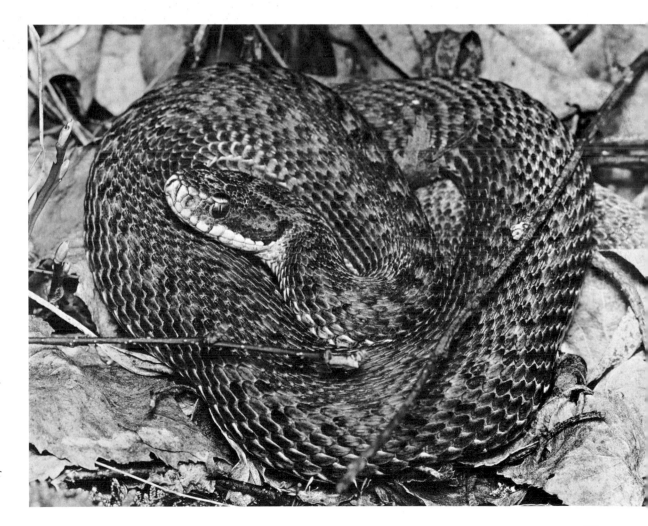

The telephoto flash is no less useful for taking large insects, frogs, retiles etc. without a tripod. This adder was taken with a Hasselblad 500C, a 250 mm Sonnar set at 2.5 metres, and two extension tubes each 55 mm long. Taking distance about 1 metre. f/22 and 50 ASA film. Braun F800 at ½ output. This gives a long enough taking distance for shy insects etc. which will not allow the photographer to come closer, at the same time as the light emission is strong enough to permit a high f-number and great depth of field. If you need to get even nearer, Proxar lenses are the most practical solution.

Smaller mammals

Batrachians and reptiles will usually keep still for long periods if you avoid frightening them. Small animals are more difficult and a glass cage made of four separate sheets of glass (plate glass for the side nearest to the camera) joined at the tops by wooden blocks is one answer. Part of the animal's natural surroundings can be put inside it. Do not work in the sun because it will reflect in the glass. Use a flash in dull weather. The light inside the cage will then be brighter compared to the light outside, and the reflections will be outshone. The flash lighting must not play on the camera: avoid this by using a short tele-photo lens. Sometimes the animals themselves can take the picture. We have already considered photo-electric cell arrangements (p. 87). Mechanical arrangements are simpler, e.g. a trip wire which closes a circuit to an electro-magnet on the camera or which directly actuates the flash. Then the camera is left with the shutter open, which in turn requires darkness. The latter method was used for the picture of the brown rat. Under the sacking in the picture was a pedal contact which was actuated by the rat as soon as it came padding along the edge of the corn bin. We had set up our three cameras with the shutters open. There was a battle going on for the grain, until the flash went off and the rats rushed off bumping walls in their frenzied search for the exits. Many animals do not react in the slightest to an electronic flash. We closed the shutters of our cameras, advanced the film and then opened the shutters again. Ten minutes later the rats were back, and after 30 minutes one of them trod on the contact

again. This sequence of events occurred three times during the night (= 9 pictures). If an arrangement of this kind has to be kept at the ready for half a day or more, the batteries of an electronic flash may not last. The otherwise antiquated flash bulbs may then come in to their own again, if one can use a fast enough shutter speed. Cameras rigged up outdoors must be shielded from the damp with plastic bags, and ought to be camouflaged too, both for the animals' sake and to prevent them from developing legs. The only safeguard against condensation on the lens (hoar frost during winter) is to have the deepest possible lens hood. Automatic exposure cameras have opened up new possibilities for working with camera traps in daylight. Automatic exposure setting is also a great advantage for remote control if it can be combined with motorization.

Pedal contact made from two relay contacts. It can also be used with trip wires: the wires are attached to the ring.

Self-portrait of a brown rat. Hasselblad 1000 F with an 80 mm Tessar. Protechnica Probatus electronic flash, 1/5000 sec. Agfacolor CT 18.

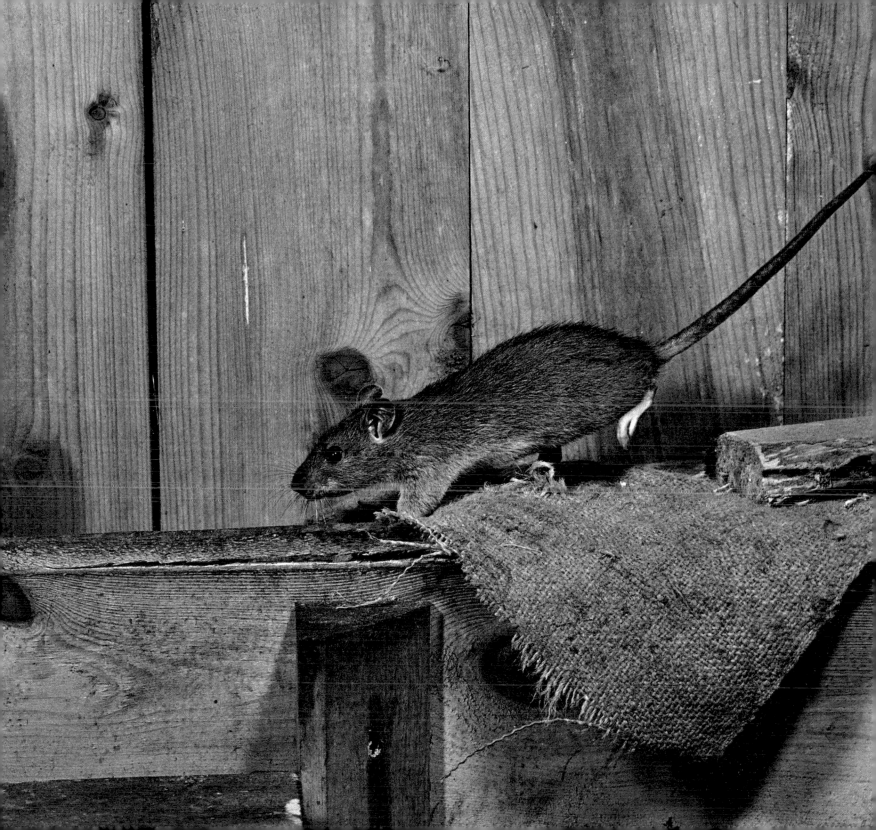

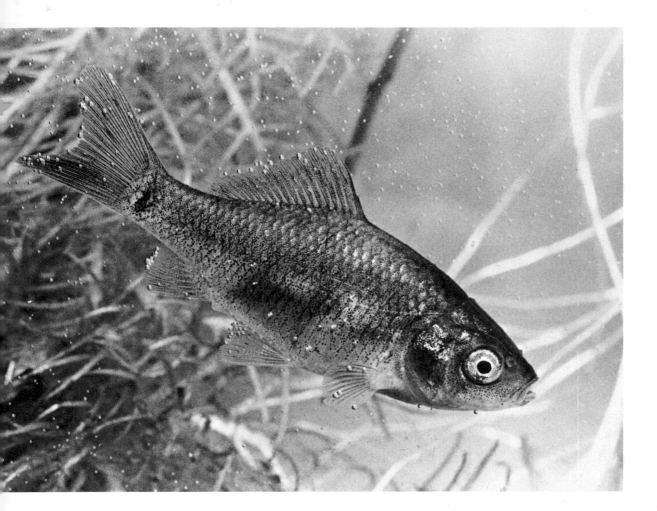

This carp was photographed in a freshwater aquarium. The air bubbles were due to the cold water getting warmer. This is the kind of soft lighting that can be obtained with a small fish and a large flash reflector at close quarters. For this picture the flash was held above the camera and to one side. Nikon F with a Micro-Nikkor and a Protechnica electronic flash with one lamp.

Here I am holding up a notebook to relieve the shadow. If one pair of hands is not enough, there is always the expedient of a cable release actuated between one's teeth.

Vivarium and aquarium

Small mammals, batrachians and reptiles can also be photographed in a vivarium, where one tries to construct a natural environment for them. Often this is one's only chance of obtaining educational pictures within a reasonable space of time, but the method is unsatisfactory for the photographer who prefers natural pictures.

Where aquatic life is concerned, aquarium photography is the only possibility open to most people. The side facing the camera must be made of flawless plate glass. The camera must be positioned at right-angles to the glass, or the sharpness will be impaired. Cold water in an aquarium which is in a warmer room soon begins to emit countless small air bubbles which fasten on the walls of the aquarium and on everything inside it. The use of boiled water is one way of avoiding these bubbles; another way is to use an

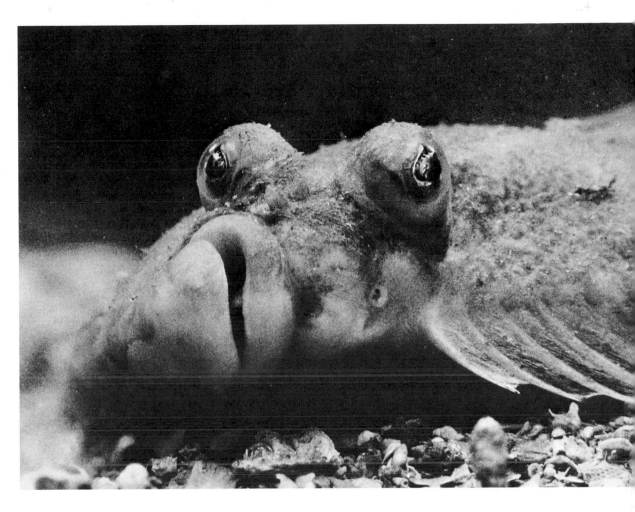

The portrait of the flounder was taken in this saltwater aquarium, with running water. One flash was aimed straight down into the water, while the other was aimed at a downward angle from the front. I put black cardboard over the edge of the table to prevent reflections in the aquarium glass, and I also surrounded the camera lens with black cardboard (held in place by the lens hood) so as to prevent reflections from my hands and from shiny parts of the camera.

aquarium with running water. Otherwise one can only wait for the water to rise to room temperature. It is not always easy to construct natural surroundings for aquatic creatures when they live on muddy lake beds and stir up clouds of detritus. This needs an aquarium with clean, fresh water flowing through all the time, otherwise the water will not clear for several hours and deposits will accumulate on the sides. When the water has settled release the animal into the

water and you may get in an exposure or two before the water clouds up again. A flash light meter to measure the light reflected from the subject in the water is a first-class aid as a lot of light disappears en route through the water. If cold water is kept flowing through the aquarium mist may form on the sides. This can be cured with a warm fan, e.g. a small hair-drier, which can be secured to a stand.

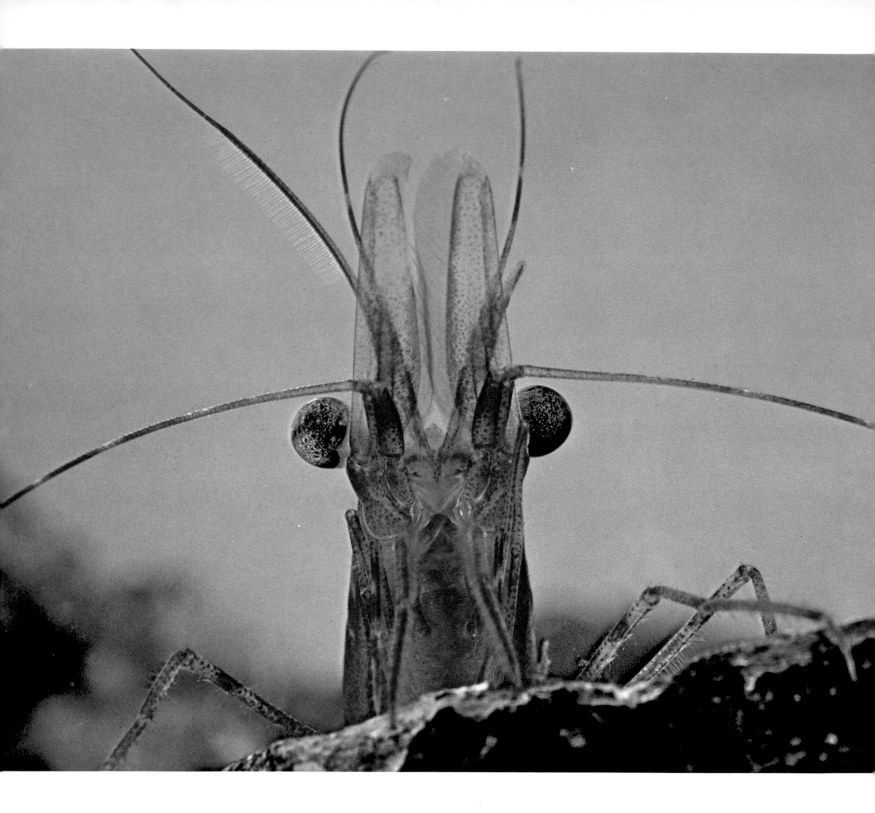

Smaller aquatic animals

The portrait of the bulbous-eyed prawn (*Pandalus borealis*) was taken in the same aquarium and with the same lighting as are shown on page 97. There must not be too much water between the subject and the front window. With fast moving animals, an extra sheet of glass may have to be inserted just behind the front window to keep them within range. Animals as small as the water louse on the right are best photographed in a cuvette. Those that can be bought ready-made do not normally have the right quality glass for photography, and they are hard to clean. It is easy to make a dismountable cuvette yourself. The one shown is made of ordinary colour slide glass measuring 7 × 7 cm. Between the two pieces of glass I have inserted a transparent U-shaped plastic tube. The thickness of the tube determines the depth of the cuvette so long as it is not too severely compressed. It is held together on three sides with waterproof tape. Fill it with water with a hypodermic syringe or a similar implement. For very small animals I use a plexiglass insert (as shown). One of the short sides is movable so that the proportions of the insert can be adjusted to the film format. You cannot fit a ring flash straight onto your lens when working through glass, because this sets up reflections. But you can mount the flash in a holder above the cuvette. This will give you a beautiful combination of falling and penetrating light, one half of the ring flash being in front of the cuvette and the other behind it. Every detail of the water louse, and the partial translucence of its body, comes out clearly in this penetrating light. The ring flash holder is made from a piece of sheet metal and is secured with a rear lens cap which has been filed down to suit the thickness of the metal and pierced with a hole (thus serving as a lens hood).

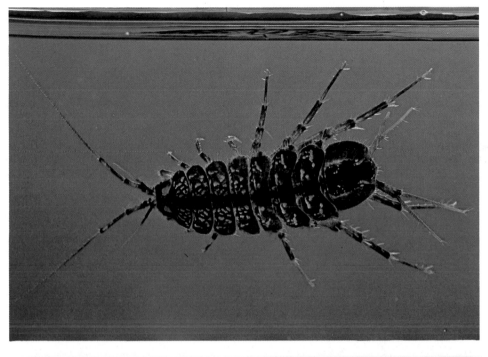

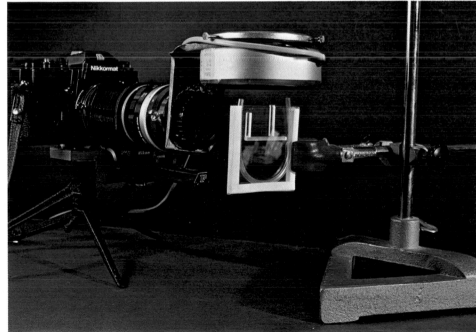

Close-up and macrophotography

See also p. 50.
The terms close-up and macro tend to be used indiscriminately, and there is indeed no hard and fast boundary between them, but the following rule of thumb can be given:

Close-ups are taken from the closest focus of the normal lens (usually about 50 cm) up to a scale of 1:1.

Macrophotography goes from a scale of 1:1 to 20:1 (× 20 enlargement on the film).

Microphotography comes within the range of the microscope. An ordinary optical microscope can enlarge to between (3—) 20 and 1000 times. For greater magnification than this, an electron microscope is needed.

A scale of 1:1 represents something of a boundary. Even here (with an extension twice as great as the focal length) one needs to have four times as much light passing through the lens as when the lens is set at ∞. Above 1:1, one's picture is a direct enlargement onto the film, and the increasing problems this involves are equal to the square of the magnification. It is difficult to get enough depth of field, and the sharpness is liable to be spoiled. To increase the depth of field significantly stop right down, but this in turn increases the danger of blurring due to:

1 the diffraction of light at small apertures
2 slow shutter speed combined with movement by the subject or wind vibrations in the subject and/or in the camera set-up
3 vibrations from the upward movement of the mirror
4 shutter vibrations (1/30-1/1 sec. are awkward speeds for focal plane shutters)
5 tripod and camera shake resulting from the transmission of the photographer's movements via the ground.

One can therefore understand a macrophotographer who uses his electronic flash to solve the above problems (except no. 1) and who accepts the disadvantages of unnatural lighting and unpredictable reflections. Or he may take the tiny subject home to his studio. If you are unwilling to sacrifice the natural environment and lighting, some of these problems can be solved as follows:

(2) 'Shore up' the subject, use a wind shield and wait for the wind to die down. Even on a windy day you can generally count on a few quiet seconds every now and then.

(3) Lock up the mirror before making the exposure, if your camera has this facility. Otherwise:

(3-4) use a shutter speed of several seconds (possibly with a neutral density filter in front of the lens — check the focusing after you have mounted the filter). Set the shutter on B, put a dark cap or suchlike (make sure the sun is not shining on it) in front of the lens, open the shutter with the cable release but hold the cap in front of the lens until the camera is steady again. Remove the cap, count the seconds and then close the shutter again. If your camera has a leaf shutter, any speed can be used without risk of vibrations from the shutter. The reciprocity error: see p. 113.

(5) This problem is worst in marshy terrain or on very thick moss. If sheer relaxation on your part is not enough, one solution is to set the self-timer and retreat to firmer ground. There is also the possibility of remote control.

In macrophotography, the ring flash can come so close that most of the light hits *behind* the subject. If there is room for the lens inside the ring flash, the latter can be retracted if the lens does not obstruct the lighting. If it does, or if there is not room for the lens inside the ring flash, you can build a close-up flash unit. The parts for this unit are spares for the smallest of the Braun electronic flashes. They are mounted on a metal sheet, which is bent to give the angles and distances required. Here the flash has been mounted onto a 24 mm Nikkor. Reversed wide-angle lenses are ideal for macrophotography. If they have floating lens elements, the lens must also be set to the closest focus.

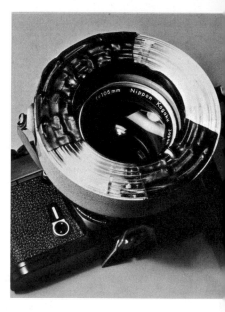

Here the Minicam ring flash has been masked off (with insulating tape) to give main lighting from one direction and shadow relief from the other. The ring flash can be turned and the direction of the lighting varied to suit the subject. Even with this masking, the flash still emits sufficient light (with a Braun F800 at half output) for a f/18 with Kodachrome II on a scale of 1:1. As will be seen, there can be *too much* light with the flash as close as this. Another advantage of masking off is that it prevents completely circular reflections from appearing on shiny subjects (p. 69).

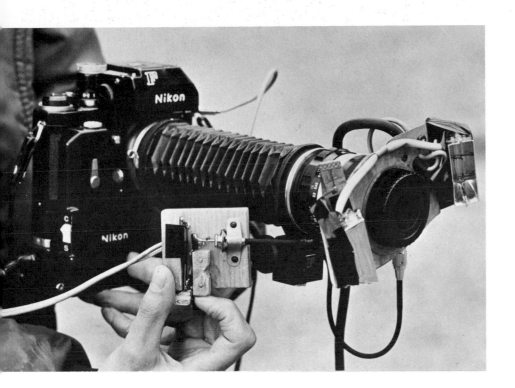

The retro-focus construction also gives you a fairly generous working distance.

When a lens is reversed, the automatic diaphragm is rendered inoperative. By using a Nikon E2 ring and connecting its cable release to a couple of relay contacts as shown, I got automatic diaphragm control at all extensions. The cable release can be held by a piece of tin in the depressed position, so that the diaphragm is fully open. The release is operated by pulling the tin with the index finger, so the cable is released and the diaphragm closes. The cable release button continues to the relay contacts and presses them together, closing the circuit to the camera motor, which is preset for single exposures. This takes a few thousandths of a second, and when the cable release is depressed again the film is advanced to the next frame.

It was also possible to make an 'automatic diaphragm' for the Hasselblad 1000F/1600F. I connected two rubber bands from a steel wire arm to the preset diaphragm knob on the Tessar. The diaphragm is held open with the index finger. When the focus is set I release the knob, the rubber bands close the diaphragm, and within the next tenth of a second I make the exposure. It has so far worked perfectly. The picture also shows a home-made close-up flash with a flash tube on either side of the lens, white-painted sheet metal behind and glass wool in front to soften up the light. This flash too can be turned as required. It can be fitted with an electric torch for focusing at night. The flash tubes are supplied from an old-fashioned heavy (5 kg) Protechnica electronic flash which, however, has paper condensers, the advantage of these being that they give as short a flash duration as 1/5000 sec.; this is often necessary in order to get fast moving insects

101

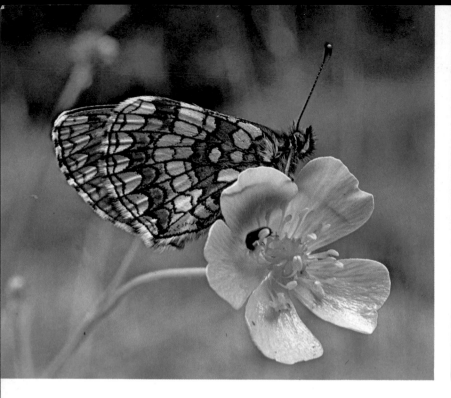

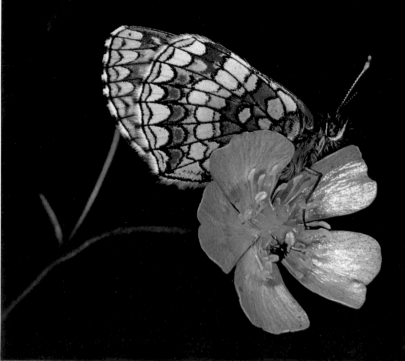

sharp enough. Modern computer flashes are capable of still shorter times, but their sensor eye has a wide angle of view and cannot pick out the important part of a subject. A computer flash will then disastrously overexpose the subject. The left-hand picture shows one method of deceiving the computer. A length of plastic string conducts light from the flash to the sensor. This locks the computer in the fastest (and the weakest) setting, 1/12,500 sec. here. If the flash can be brought close enough to the subject, there will be enough light for close-ups on a fast film. The picture opposite, where the main subject and the background are level, can be taken with an undoctored computer flash. An extremely short flash time is unnecessary. One may prefer to have more light so as to be able to stop down more. For this a piece of grey gelatine filter with two stops density can be put in front of the sensor eye, giving f/11 instead of f/5.6

On a calm day there is no point in ruining the natural atmosphere by using a flash. In dull weather, sun-loving insects like butterflies will sit still waiting for times to improve. On the other hand the beetle inside the flower is active and comes out blurred in the daylight picture (¼ sec.). Nikon F with a 55 mm Micro-Nikkor. Kodachrome II. The right-hand picture was taken with a (masked off) ring flash.

This beetle (*Saperda carcharias*) was taken with a Hasselblad 1600F and an 80 mm Tessar on a bellows attachment, using the 'automatic diaphragm' (f/22) and the close-up flash as described on p. 101. Agfacolor CT 18.

Picture sequences

showing a pattern of events such as this wasp crawling out of its pupal cell can be taken even with a slow recycling flash (5-10 secs. between pictures). *Time* adds a fascinating dimension to the pictures. The latest generation of computer flashes (e.g. Braun F900, with a recycling time of as little as 0.2 sec.) opens up new opportunities of capturing much faster processes; a series can be taken with a motorized camera at 5 frames per sec. with the short flash duration of 1/20,000 sec.

Shy insects

Larger insects can be difficult to approach. A moderate telephoto lens (90-135 mm for 35 mm work) and extension tubes or a bellows attachment are one solution. (See p. 93: telephoto flash.) For working in daylight with a slow film, you need a steady tripod. If you prefer the electronic flash, it is an advantage to have the flash unit in line with the front lens. This enables you, with a focal length of about 100 mm, to use the same aperture from the minimum to the maximum extension of the bellows. The greater amount of light needed when the bellows attachment is further extended is counterbalanced by the fact that the distance between flash and subject is then reduced. And if you have a bellows attachment which transfers the automatic aperture control (Novoflex makes such an attachment for most SLR cameras), you are equipped for stalking elusive insects. Technical advances have made it far easier nowadays to work without a tripod and, above all, to obtain pictures of animals undisturbed in their natural habitat.

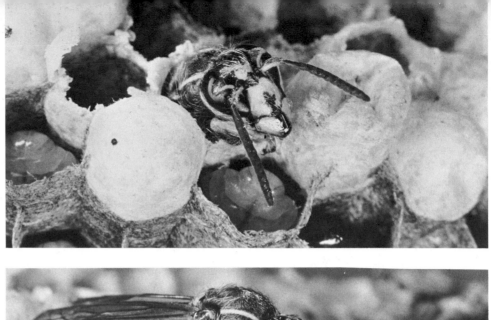

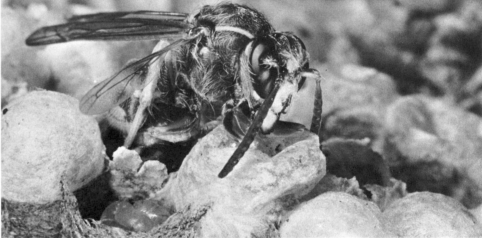

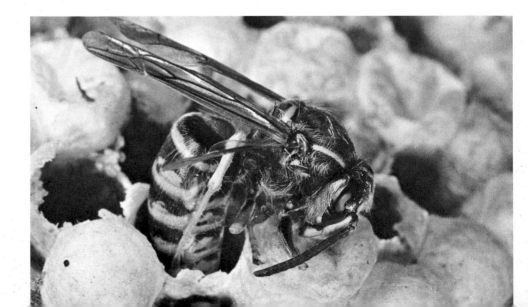

Spring-tails. Hasselblad 500C with an 80 mm Planar on a bellows attachment. The left-hand picture was taken at one-third extension, the right-hand picture with the bellows fully extended. 500 W photoflood.

A wasp emerging from the pupal cell. Nikon F with a 55 mm Micro-Nikkor, Minicam ring flash (masked off) and a Braun F800.

Sheer numbers

This myriad of spring-tails lay like patches of sawdust on the surface of a little stream. I took a number of these tiny creatures (they measure 2-4 mm) home to get some close-ups. These were taken (left) in incident light, which gave little contrast to the white bottom of the plastic beaker, and in transmitted light (from below, via the semi-opaque bottom of the beaker), which gave more of a contrast — a silhouette effect — and ruled out reflections. The photoflood gives you complete control of reflections, but it also emits a great deal of heat, with the result that plants are liable to droop and small creatures can get uneasy or even die if the lamp is kept on too long. It is therefore advisable to make the setting with a less powerful lamp. In most cases I prefer a flash.

Cases and carrying gear

A versatile nature photographer has to carry a lot of equipment about. The best arrangement is to carry your bag in a rucksack frame. This distributes the weight evenly between your shoulders. The rucksack frame shown here has been fitted with two sheets of plywood with end stops to fit the Hasselblad aluminium case. With a strap through the handle, the case will then be secured to the frame. The ordinary rucksack straps have been replaced with a harness, which divides the pressure over a wider area of the shoulders. The frame can also be fitted with a strap passing round the hips. The same rucksack frame can be used to carry the case used for Nikon or the Sinar case. The weights of the fully packed cases will convey some impression of the differences between the three formats: 35 mm, 8.2 kg; 6 × 6 cm, 12.6 kg; 9 × 12 cm, 19.6 kg.

The Nikon case is a standard British bag filled with foamed plastic which can be cut out to suit your own equipment. The case ought to be dust-proof and watertight. Fastening the carrier straps onto the bottom of this case eliminates the 2 kg of the rucksack frame, but is rather bumpy for long distances. To make things softer for the small of the back fit the bottom of the case with a PVC bag containing a folded Astron blanket (on sale in sports shops). This is excellent rainwear for both photographer and gear, and also makes a substantial (2.1 × 1.4 metres) reflector screen, as one side is aluminium coated to reflect the warmth of the human body when the blanket is actually used as a blanket.

The Hasselblad aluminium case is dust-proof and watertight, but it is heavy—4.5 kg

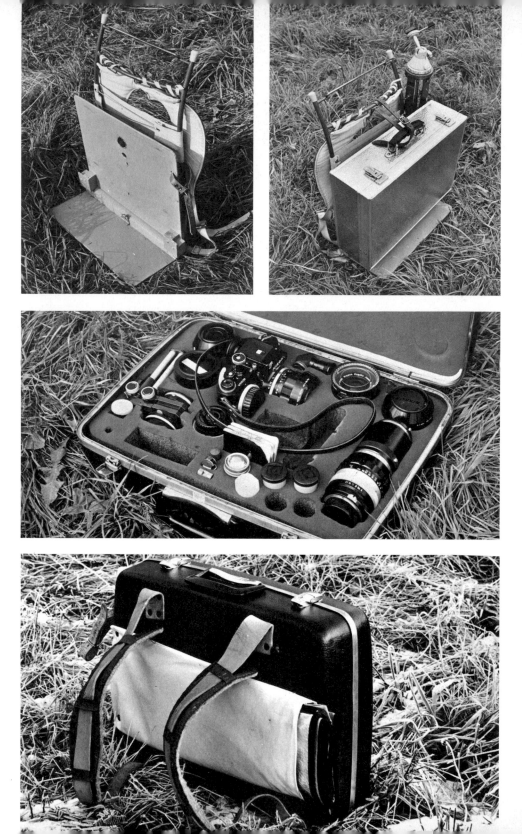

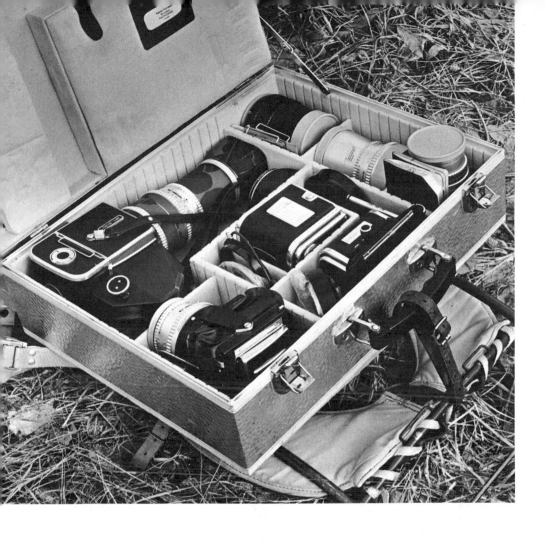

empty! It is made by the German Rox factory. Most of the partitions are movable to fit the equipment one is carrying. The hammered aluminium finish reflects heat, but also reflects the light, which is like having a large mirror on one's back. The black Nikon case keeps a decent inside temperature for film that is always sensitive to heat, thanks to the high insulation capacity of its foamed plastic. (If possible, film should be kept in a freezer until an hour or so before use, as this slows down the ageing processing. If used too soon after being taken out of the freezer condensation may form on the film.)

Quick mounts

make things easier for the photographer who uses his tripod a lot. Unless your camera has interchangeable magazines, you continually have to screw and unscrew your gear in order to work simultaneously with colour and monochrome. A wedge-shaped shoe is screwed underneath the camera and an adapter is fastened to the tripod ball joint. You mount the camera on the tripod by pushing the shoe into the adapter, where it automatically locks in position. The release button needs fitting with a guard to prevent unintentional actuation: see picture. Otherwise one may drop the camera when grasping the neck of the ball joint preparatory to moving the equipment. Quick mounts also save you the trouble of re-aligning the camera after you have changed from colour to monochrome, because the ball joint remains firmly in position.

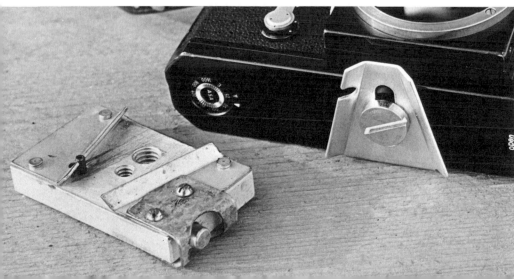

107

Filing pictures

I started by filing my pictures chronologically, so that all the pictures taken on a particular journey were kept together, and every picture had its own number. But when I began selling pictures the disadvantages became noticeable. A card index had to be compiled, with one card for every single plant and animal species, and this still left me with the task of going from one place in the files to another, so as to compare all my different pictures of a certain species. In 1964 I changed to a biological system whereby all my pictures (both negatives and transparencies) of a particular species are filed together in chronological order under the name of the species, and all my pictures of scenery filed by province. The different species within each group of plants or animals are arranged in the order used in the flora or fauna handbooks which I considered best at the time of the change-over. The animal pictures start with single celled animals and work 'upwards'. In 1964 I also converted the numbering system from continuous to six-digit numbers, in fact the dates on which the pictures were taken. All pictures taken on 11 August 1975 are put into transparent envelopes stamped 110875. In cases where an individual number is required, one can simply add a couple of digits, e.g. 110875-01, 110875-02 and so on. In fact this date reference system has many advantages. Suppose that of all my Lapland pictures I want to find those which I took in June 1972 when I visited the Sjaunja National Park. I look up the Lapland card and soon find the 0672 series. While I am looking through the provincially classified pic-

I only use glass slide mounts for pictures to be projected. For any other purpose, glass mounts are unsuitable, because they are bulky, heavy, fragile and — if they get broken — a positive danger to the pictures. Instead I use PVC envelopes and specially made labels. I use the same envelopes for 6 × 6 cm and 35 mm (with mask.)

tures, I suddenly remember that I took an unusual 'table spruce' there. The picture, of course, is filed together with the plants and, of all the spruce tree pictures I have taken, this one is easy to locate because I know that its number must end in 0672. All the writing I have to do now is to write up the first picture of the day (with the date, of course) in the monochrome notebook and in the colour notebook. A note has to be made of the number of films taken, if I use more than one. All the other particulars (the frame numbers and subjects) are noted down after the film has been developed. My notebooks give me the chronological sequence of my pictures if, for example, I should need to collect

all the pictures taken on a particular trip. I examine my films in a stereoscopic microscope, not only in order to check the sharpness etc., but also to save my eyesight. A word of warning here concerning monocular magnifiers: they can cause one eye to become overstrained.

This biological filing system works perfectly with plants and animals. It can be expanded as the need arises, and I use the same system for negatives and colour slides (picture, opposite page) for black and white prints and in the catalogue of species printed for the information of people buying my pictures. On the other hand it can take more time to locate the landscape pictures I need. If somebody orders 'a eutrophic lake' or 'a typical lichen and pine-clad moorland from the north of Sweden, showing hanging black lichens', I tackle an assignment of this kind with the aid of a card index of the different biotopes (both land and water). Once again the date reference system proves useful because a single number on the card will cover both monochrome and colour. In addition to animals, plants and scenery, I have a number of specialized groupings such as agriculture, aquaria, astronomy, camping, entomology, environmental problems, fishing, limnology, meterorology, mouldering, ornithology, photography, photosyntheses, seasonal changes in different biotopes, seed dispersal, soils and wildlife preservation.

The photographer and conservancy

The natural environment today is under heavier pressure and in greater danger than ever before. In various ways, the pictures taken by the nature photographer can help to support the forces of conservancy. His experience and frequent surveillance of nature enable him to discover abuses and give warnings at local and national level. He must have a sense of responsibility, and use his camera honestly and objectively.

Naturfotograferna (/N) was set up in Sweden in 1966 for the promotion of skilful and truthful nature photography. Today the Association has 43 members in Sweden. /N condemns all use of stuffed animals for the depiction of natural conditions, as well as employing tame or captive animals for dramatization purposes. While not opposing the reasonable use of pictures of tame animals, /N maintains that pictures of this kind should be accompanied by a declaration of provenance, which should also be published. /N also exists for the encouragement of humane behaviour in contacts with nature and wildlife.

There is a similar society in Germany, called Gesellschaft Deutscher Tierfotografen (GDT). In a country whose natural environment is constantly threatened by industry and intensive land exploitation, nature photographers tend perhaps to be unusually aware of the precarious condition of living things and of the great care and consideration that need to be shown. GDT has published an exhaustive brochure setting out guidelines for nature photography and among other things counselling against photography in the vicinity of the nests of various species.

In the United Kingdom, the First Schedule of the Protection of Birds Act enumerates protected species which may only be photographed by persons issued with permits by the Natural Environment Research Council. The full list of species protected at all times is as follows:

Avocet	Osprey
Bee-eater (all species)	Owl, Barn (England and
Bittern (all species)	Wales only)
Bunting, Snow	Owl, Snowy (Scotland only)
Bustard	Peregrine
Buzzard, Honey	Phalarope, Red-necked
Chough	Plover, Little Ringed
Corncrake (Landrail)	Quail, Common
Crossbill, Common	Redstart, Black
(England and Wales only)	Roller
Curlew, Stone	Ruff *and* Reeve
Diver, Black-throated	Shrike, Red-backed
Diver, Great Northern	(England and Wales only)
Diver, Red-throated	Sparrow Hawk (England
Eagle (all species)	and Wales only)
Goshawk	Spoonbill
Grebe, Black-necked	Stilt, Black-winged
Grebe, Slavonian	Stint, Temminck's
Greenshank	Swan, Whooper
Harrier, Hen	Swan, Bewick's
Harrier, Marsh	Tern, Black
Harrier, Montagu's	Tern, Roseate
Hobby	Tit, Bearded
Hoopoe	Tit, Crested
Kite	Warbler, Dartford
Merlin	Warbler, Marsh
Oriole, Golden	Wren, St. Kilda
	Wryneck

Nor must we lose sight of the main threat to the plant and animal kingdoms, which is the increasingly industrialized exploitation of natural resources. Slogans like 'optimum utilization of the country's timber resources' conceal an enormous threat to wildlife, to a variegated and humane landscape and to an abundance of animal and plant species. Like human labour itself, natural resources cannot be subjected to 'optimum utilization' without many of the finest elements of our living environment being destroyed.

Glossary

Automatic diaphragm. This is an arrangement whereby the lens is automatically stopped down when the camera is actuated. In this way one can observe the subject with the lightest possible viewfinder image (full aperture) right up to the moment of exposure. This refinement is now a standard feature of all 35 mm and medium format SLR cameras. Extension tubes and bellows attachments transferring the automatic diaphragm control from the camera to the lens are also becoming increasingly common. But there are as yet no commercially available devices for the retention of automatic control with reversed lenses. A home-made arrangement of this kind is described, however, on p. 101.

The closest focus is the shortest range to which a lens can be set without accessories. Normal lenses in SLR cameras generally have a closest focus somewhere between 0.4 and 1.0 metre.

Close-up lenses are placed in front of the camera lens. Generally positive lenses are used. These shorten the focal length of the ordinary lens, facilitating close-up photography even with a camera with a non-interchangeable lens. Of course, they can also be used on cameras with interchangeable lenses, but they do not give the same magnification as can be obtained with extension tubes or bellows attachments. Unlike the latter, close-up lenses have little effect on the light transmission power of the ordinary lens. This means that close-ups without a tripod can be taken more easily with close-up lenses than with extension tubes. The power of a close-up lens is measured in diopters. If a lens without a close-up lens attached can be focused between ∞ and 1 metre, the addition of a close-up lens of 1 diopter will shift the focusing range to between 1-½ metre. With two diopters the focusing range will be ½-⅓ metre, and with three diopters it will be ⅓-¼ metre. Not more than two close-up lenses should be used at a time, unless one is prepared to accept a deterioration of definition. Even when using only one close-up lens, one should stop down by at least two stops.

Colour temperature is not really a temperature at all but a designation referring to the colour of incandescent light, which is measured in Kelvin degrees (°K) or mired. The light for which daylight colour films are balanced has a colour temperature of 5500°K or 180 mired, corresponding to a mixture of sunlight and blue skylight.

Computer flash units (otherwise known as sensor flashguns or automatic flashguns) are electronic flashes equipped with a small photo-electric cell which reads off the flash lighting reflected by the subject and extinguishes the flash tube when the subject has received enough light for the preselected aperture (the taking aperture).

Diopter: see close-up lenses.

Emulsion is the light-sensitive layer superimposed on the film base. The thinner this layer is, the better the resultant definition is likely to be. Colour films are made up of several layers, but Kodachrome films have the thinnest emulsions, because they comprise three monochrome layers—the dyes are added during processing—unlike other films, which have to incorporate dyes from the very beginning.

Floating lens elements. This term implies that, during focusing, certain groups of

lenses are shifted in relation to others. In this way good definition can be obtained when the lens is being used at close range. At present the system is used in a small number of wide-angle lenses with which it used to be difficult to obtain good correction throughout the focusing range.

A focal plane shutter resembles a curtain with a slit in it which is rapidly moved sideways or vertically past the film. The duration of the resultant exposure is determined by the width of the slit and the speed of the curtain. At speeds of 1/60 sec. (1/125 or 1/30 in some cases) and longer, the curtain aperture equals the area of the film gate, thus exposing the whole frame at the same time. It is only at these speeds that the focal plane shutter can be synchronized with electronic flash units. Flash bulbs with a long enough flash duration can also be synchronized with shorter exposures. Owing to the slow shutter speeds used with electronic flashes, it may be difficult to avoid double exposure in good general lighting, e.g. when a flash is used in sunlight to relieve shadows ('fill-in flash'). Other disadvantages of the focal plane shutter are its relative noisiness and its tendency to set up vibrations (cf. Leaf shutter). Because the focal plane shutter is mounted immediately in front of the film plane, it is easy to construct this kind of camera for interchangeable lenses and, given suitable adapters, focal plane cameras can also be combined with lenses of other makes. Another advantage is the fast shutter speeds (down to 1/2000 sec.) obtainable with these shutters.

Focus difference. Because white light is a mixture of all the colours of the spectrum, and because lenses can never refract all wavelengths of light to exactly the same point, a focus difference results in light of different wavelengths. In the case of ordinary lenses, this only needs to be taken into account when working with ultraviolet ('black') light (p. 60) or with infra-red lighting. Most lenses have a special red mark to which the range setting has to be moved for infra-red work.

Gelatin filters are manufactured by casting sheets of gelatine solution combined with the requisite dye. Gelatine filters can be produced in a very wide range of colours and are cheap to buy, but they are sensitive to grime and easily scratched. They used to be sold enclosed in glass, but this version has been superseded by solid glass filters, which are available in the commonest colours.

Image field diameter is the diameter of the circular picture that the lens is capable of reproducing with an acceptable standard of quality. It is generally stated with reference to ∞ and an aperture of about f/16 (or sometimes at full aperture, in which case the diameter will be smaller).

Integral light meters are a form of TTL light meters in which the light sensitive cells 'read' the entire area (or practically the entire area) of the focusing screen. The opposite is spot meters, in which the metering is confined to a small portion of the angle of view, usually a circle of a few millimetres in the centre. An intermediate arrangement is centre-weighted meters, where, for instance, in the Nikon 60 per cent of the metering takes place in the centre within a circle 12 mm in diameter while the remaining 40 per cent is measured outside. There are several variants, including cameras which can be switched from spot to integral metering.

Spot metering is to be considered as most accurate, but it demands more time and thought. Integral metering is faster but can be misleading for pictures which incorporate extreme lighting contrasts (p. 46).

A leaf shutter (otherwise known as a between-the-lens shutter) is generally mounted in the diaphragm plane of the lens and comprises a number of thin steel plates, known as shutter leaves or shutter blades, which open out from the centre of the lens when an exposure is made. Leaf shutters can be synchronized with electronic flash units at all shutter speeds. They operate silently and without vibration, and they provide an even exposure of the whole picture area. On the other hand they are not capable of the same high shutter speeds as focal plane shutters, and their maximum aperture is also limited. (For instance, the Tele-Tessar 500 mm for Hasselblad is incapable of 1/500 sec. at wider apertures than f/8. The maximum aperture of the corresponding lens for the Rolleiflex SL 66, which has a focal plane shutter, is f/5.6.) All leaf shutters in SLR cameras have to be combined with an auxiliary shutter to shield the film from the light before exposure. The auxiliary shutter (and mirror) are noisier and more prone to vibration than the leaf shutter. When using a tripod, this disadvantage can be overcome if the mirror and auxiliary shutter can be actuated in advance.

Macro lenses. The same lens cannot be equally well corrected for all taking distances. Most camera lenses are calculated for long-distance use. Macro lenses on the other hand usually perform best on a scale of 1:10 (and ought therefore to be termed 'close-up lenses', cf. p. 100), but dispensing as they do with the widest apertures, they also give excellent picture quality at other distances. Reversed they are suitable for 'real' macrophotography too. Some lenses, generally distinguished by small dimensions and the absence of automatic diaphragm control and focusing, are genuine macro lenses (e.g. the Zeiss Luminar). These are used solely within the macro range and are not to be reversed.

Panchromatic film is balanced to give a grey scale which agrees with the apprehension of the human eye of the lightness of different colours.

Parallax occurs, for example, in cameras where the viewfinder is separate from the lens (though not in SLR cameras, where the viewfinder and the film are served by the same lens). The viewfinder and the lens do not see the same picture at all distances, unless there is some kind of correctional device between them. Similarly, close-up flashes have to be capable of alignment according to the taking distance.

Preset diaphragm. This means that, before making the exposure, you have to stop down manually, by means of a special ring or knob, to the preset f-number. Nowadays preset diaphragms are mostly confined to certain of the longer telephoto lenses and PC or shift lenses, which it is sometimes difficult to provide with an automatic diaphragm control.

The reciprocity error. Very simply, the *law* of reciprocity says that the exposure effect must be the same irrespective of whether you use a fast shutter speed (and a wide aperture) or a slow shutter speed (and a correspondingly smaller aperture). This more or less holds good for shutter speeds between 1/1000 and 1/1 sec., but at speeds outside

these limits the film no longer reacts proportionally. It then requires more light than the exposure meter indicates. For present purposes, the longer exposure times are of particular interest. Practical exposure tests have yielded the following results, though it should be borne in mind that the error can vary from one emulsion to another.

	Exposure time according to meter	Exposure time actually needed
ILFORD PAN F 135	2 sec.	= 3
	4 "	= 10
	8 "	= 32
	16 "	= 55
ILFORD FP 4	1 "	= 2
	2 "	= 3
	4 "	= 8
	8 "	= 20
	16 "	= 32
KODACHROME II 135	1 "	= 1½
	2 "	= 5
	4 "	= 12
	8 "	= 45
	16 "	= 90
AGFACHROME 50S 120	1 "	= 2
	2 "	= 4
	4 "	= 8
	8 "	= 20
	16 "	= 32

Spot meter: see Integral light meters.

Taking distance is the name commonly given (particularly in close-up/macro-photography) to the distance between the front lens and the subject.

Zoom lenses. The focal length of this type of lens can be altered by displacements in the lens system. The maximum focal length range for still picture zoom lenses is usually x6, e.g. from 50 to 300 mm. The advantage of a zoom lens is that it combines 'several lenses in one' and that it facilitates a quick and continuous alteration of focal length. Instead of walking up to or away from his subject (which he does not always have the time or the opportunity for), the photographer simply turns or slides a ring. In colour photography particularly, it is a great advantage to be able to make full use of the format. The disadvantages are weight—for high quality pictures the zoom lens has to contain up to 20 lens elements—and loss of speed. Zoom lenses are also fragile. Close-ups are hard to take with a zoom lens, because if you want to get beyond the closest focus, close-up lenses are often the only possible arrangement. A new type has appeared, however, in the form of what are called macro-zoom lenses, which apart from their adjustable focal length also have a special position for close-ups. These lenses may develop into something of a universal lens, but so far they do not appear to give close-ups of the same quality as ordinary macro lenses.

Further reading

Angel Heather: *Nature Photography, its art and techniques.* 1972

Baufle-Varin: *Photographing Wildlife.* 1972

Eric Hosking and C. Newberry: *Bird Photography as a Hobby.* 1961.

Eric Hosking and John Gooders: *Wildlife Photography, a Field Guide,* 1973

Kinne, Russ: *The Complete Book of Nature Photography,* 1971

Lintin, D.: *Photographing Nature.* 1965

Mertens, Lawrence: *In-water Photography.* 1970

Papert, Jean: *Photomacrography: Art and Techniques.* 1971.

Photographing Nature: LIFE Library of Photography. 1971.

Urry, David and Katie: *Flying Birds.* 1970

Index